Another Coloring Book
TO CALM, RELAX AND ENJOY

Another Coloring Book
TO CALM, RELAX AND ENJOY

By Tin
J Art & Design
All Rights Reserved. No portion of this book may be copied in any form without the Authors Permission.
https://www.facebook.com/J.art.1157/

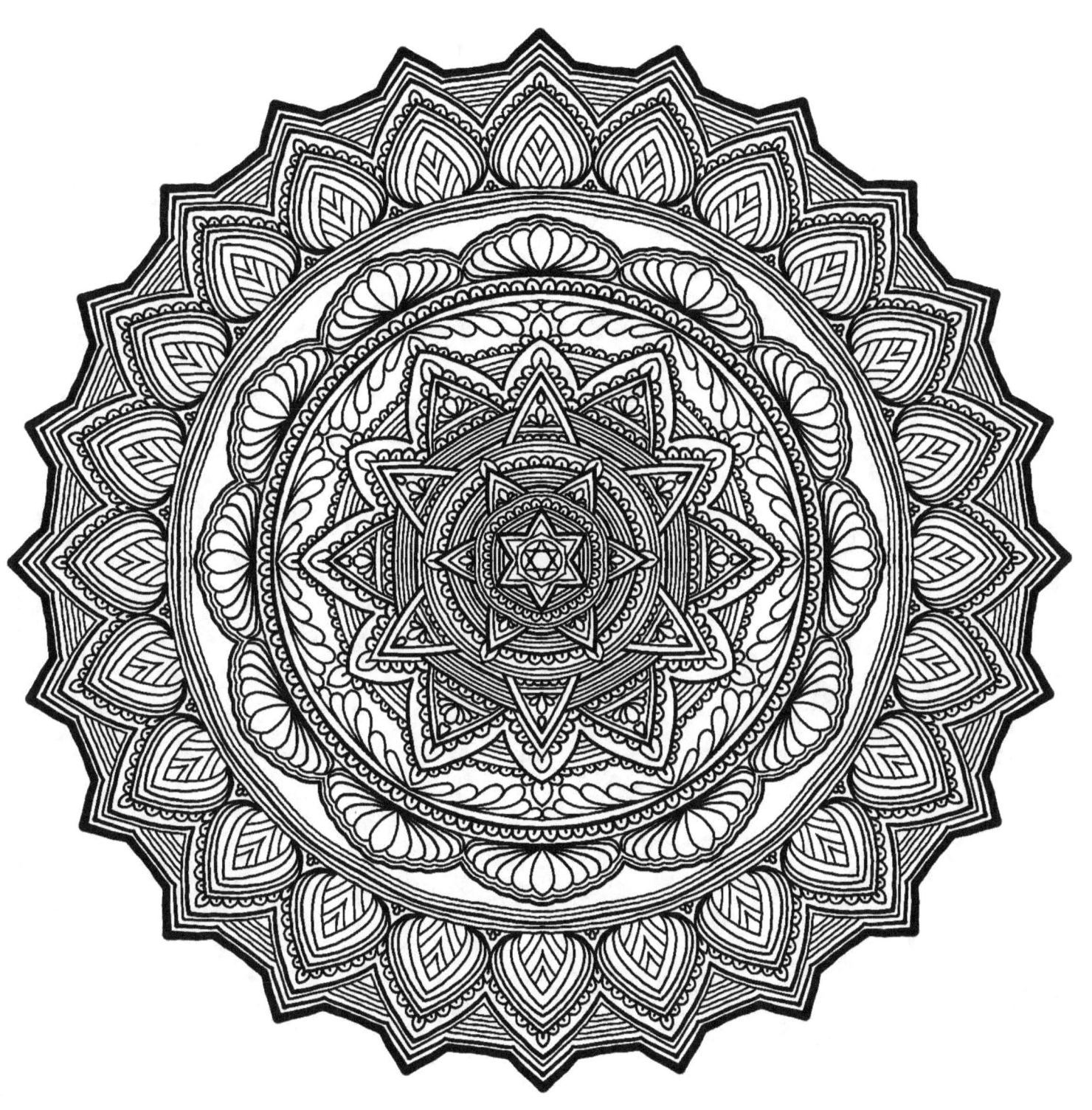

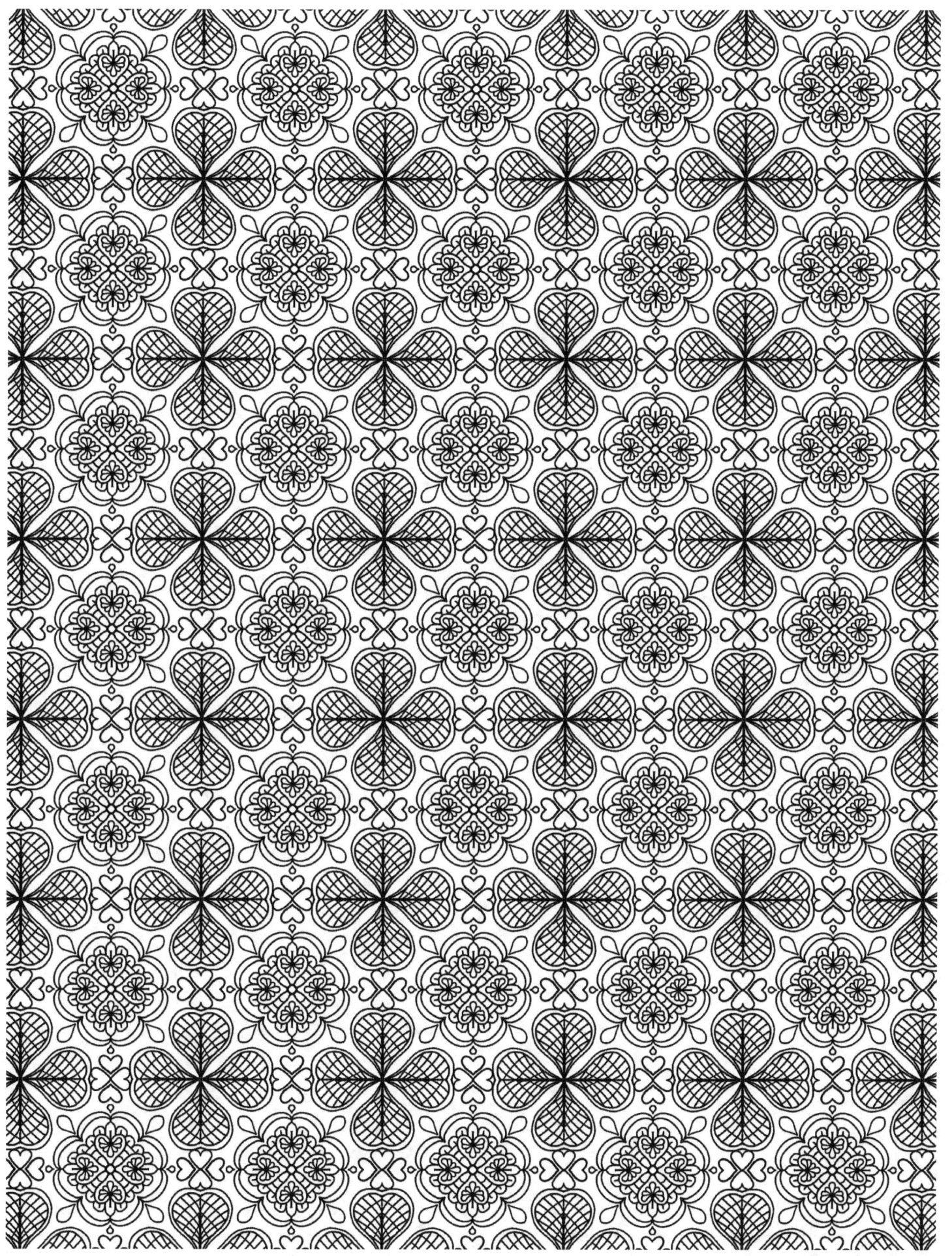

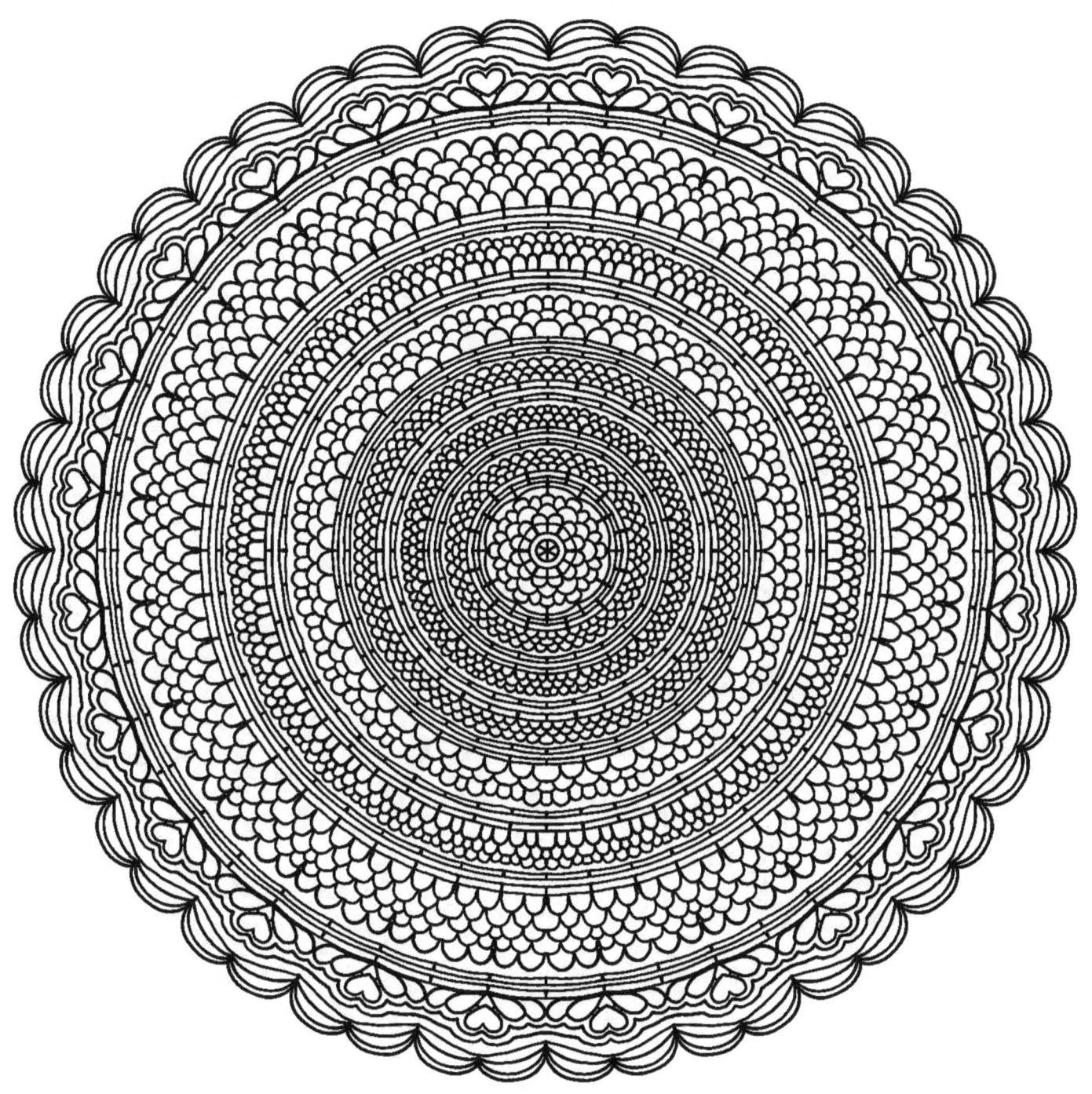

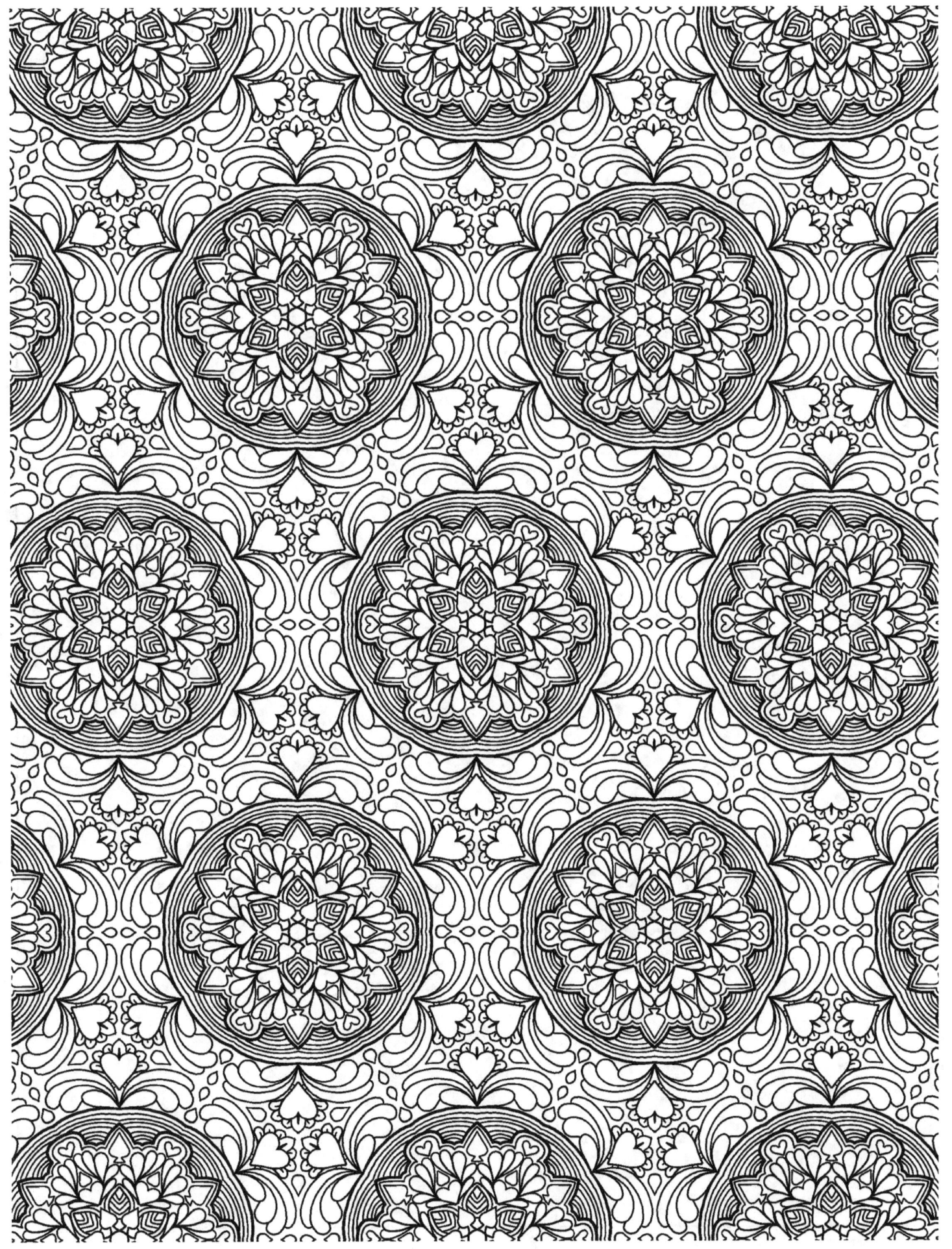

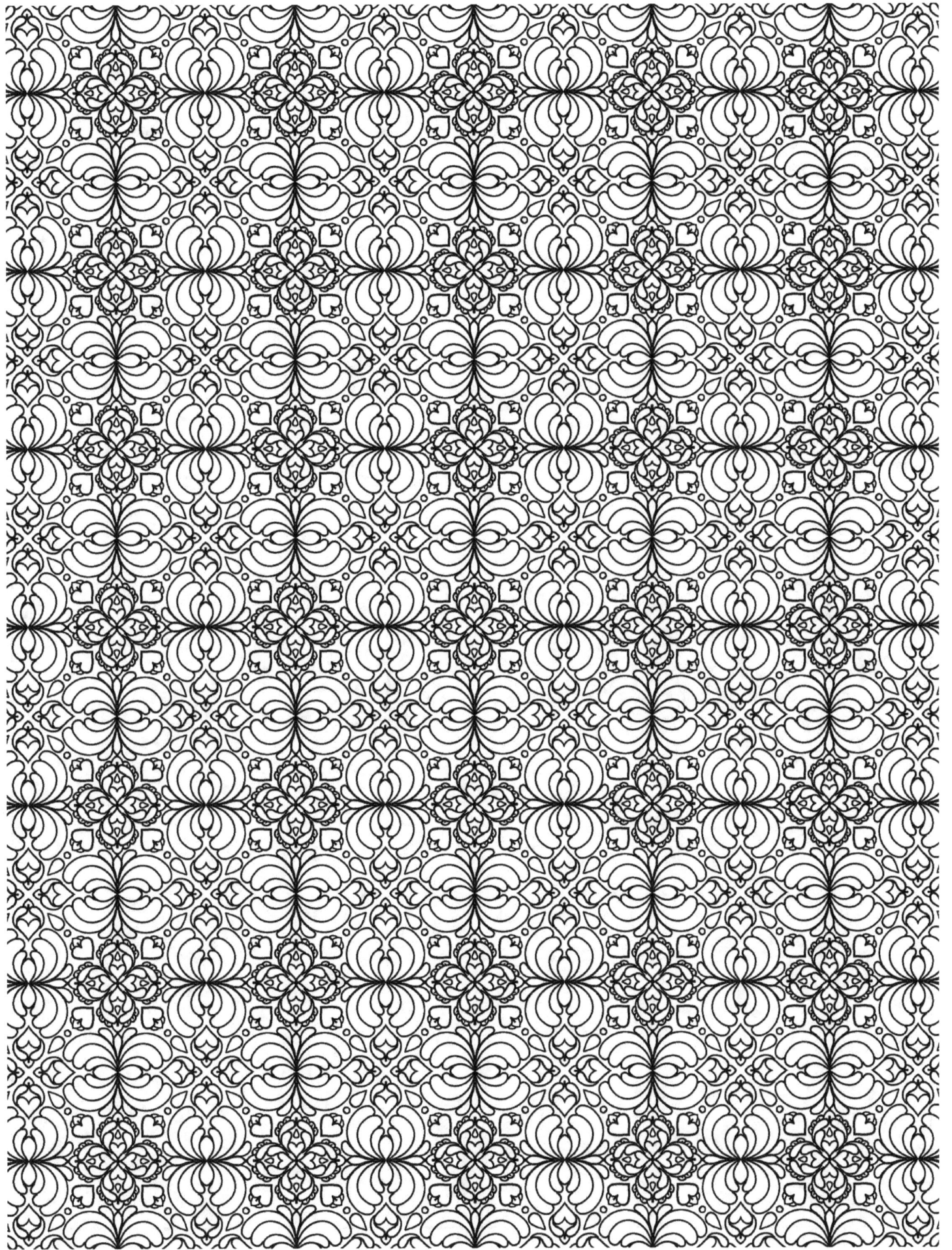

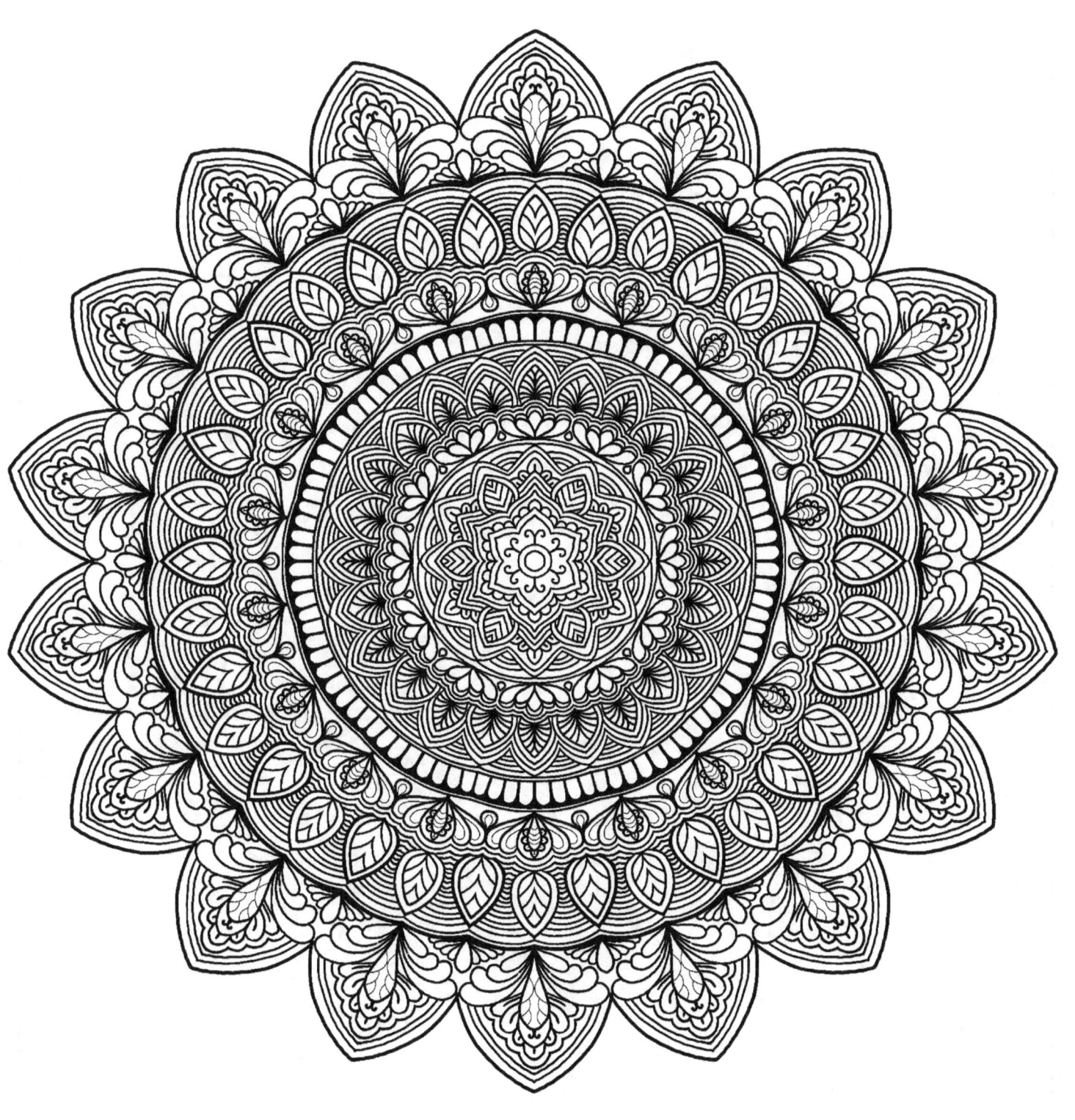

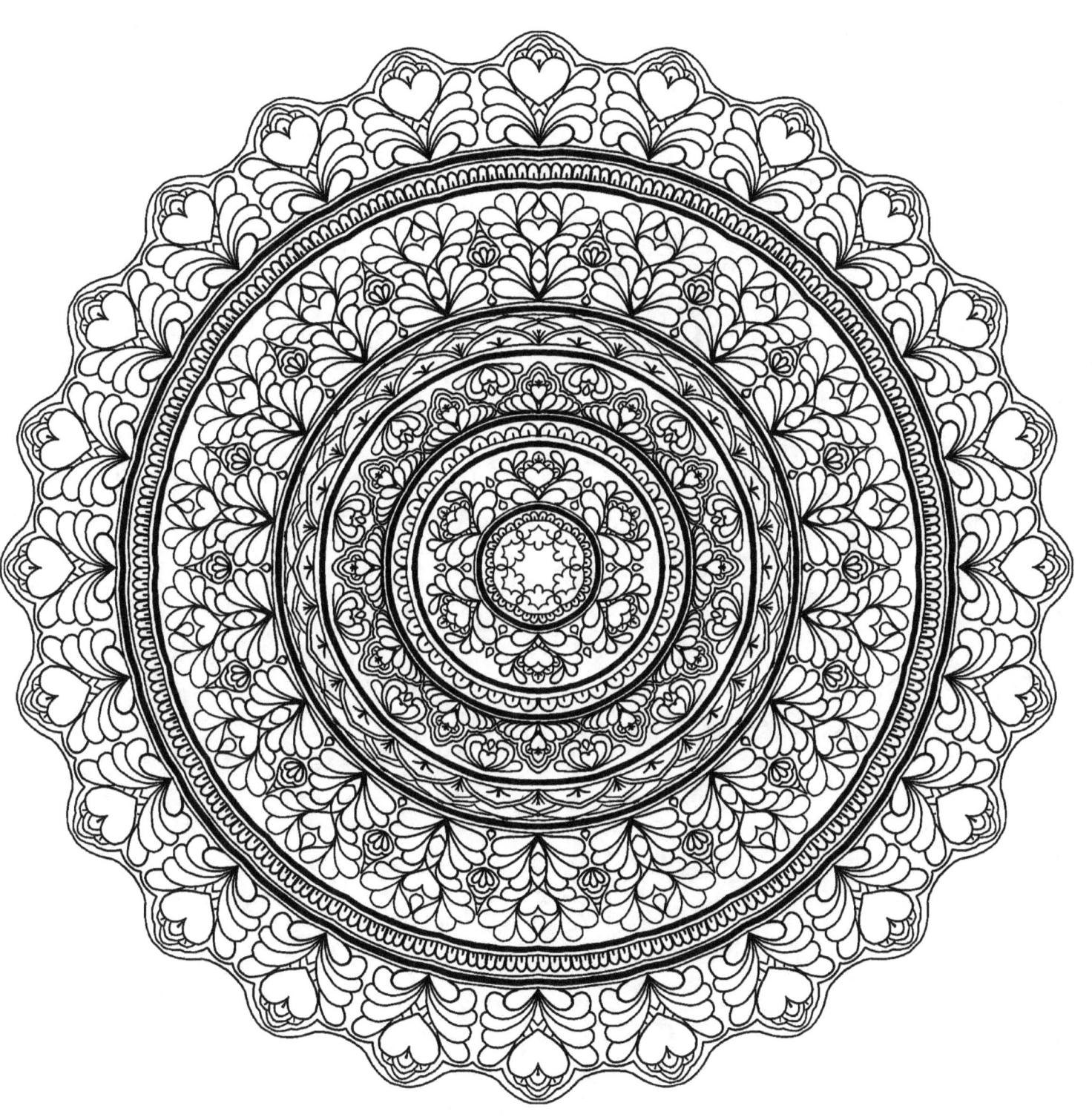

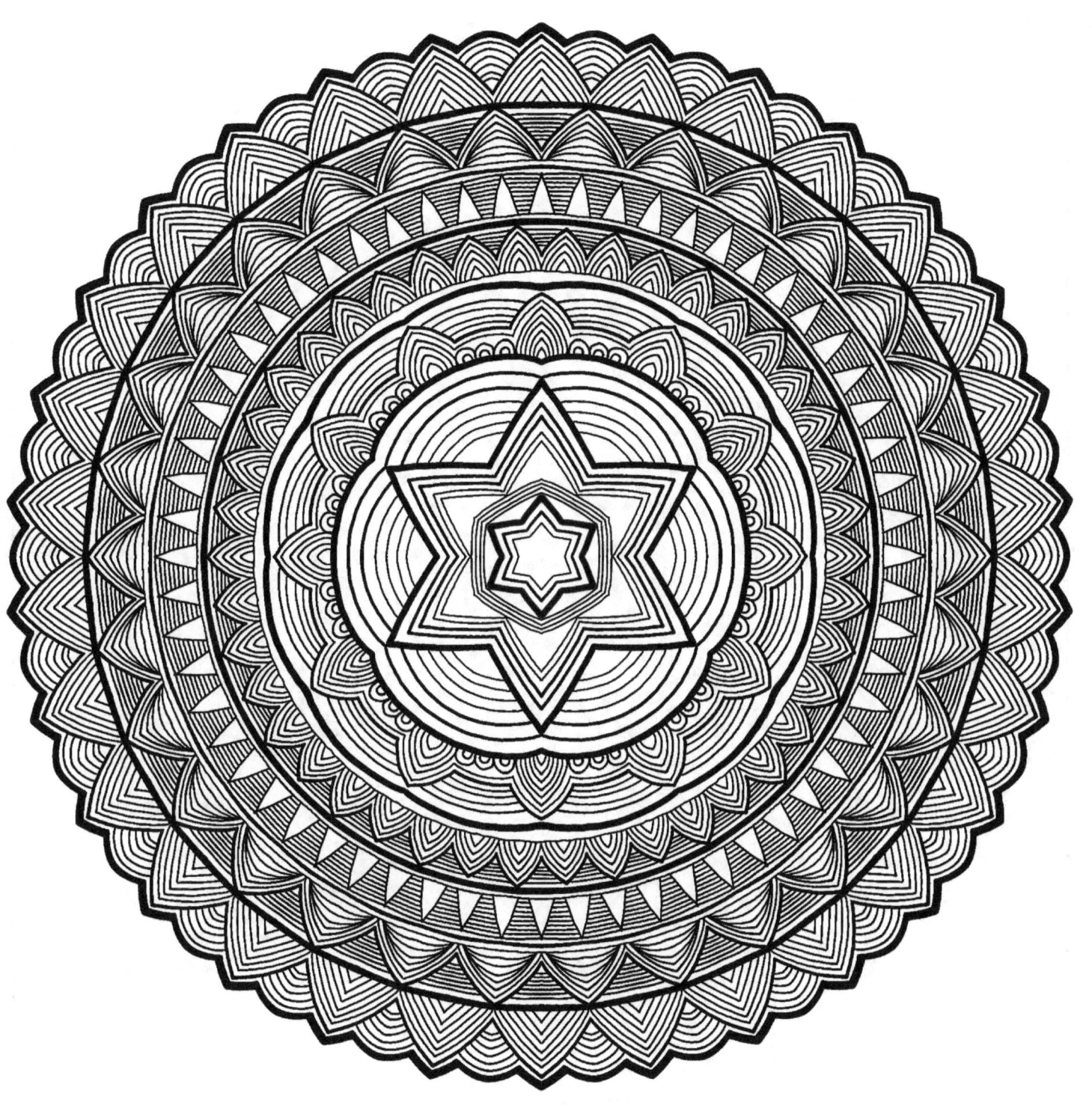

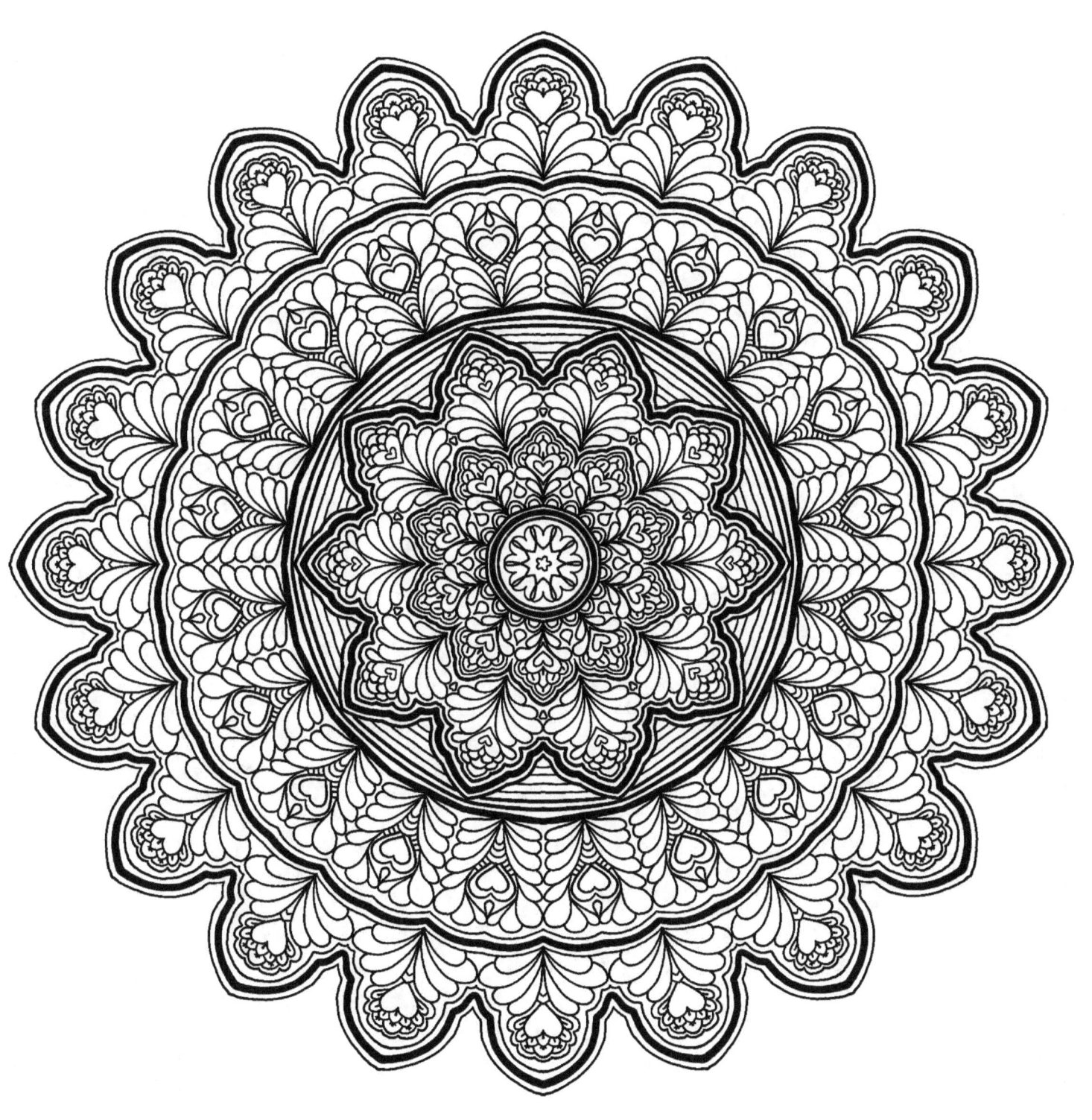

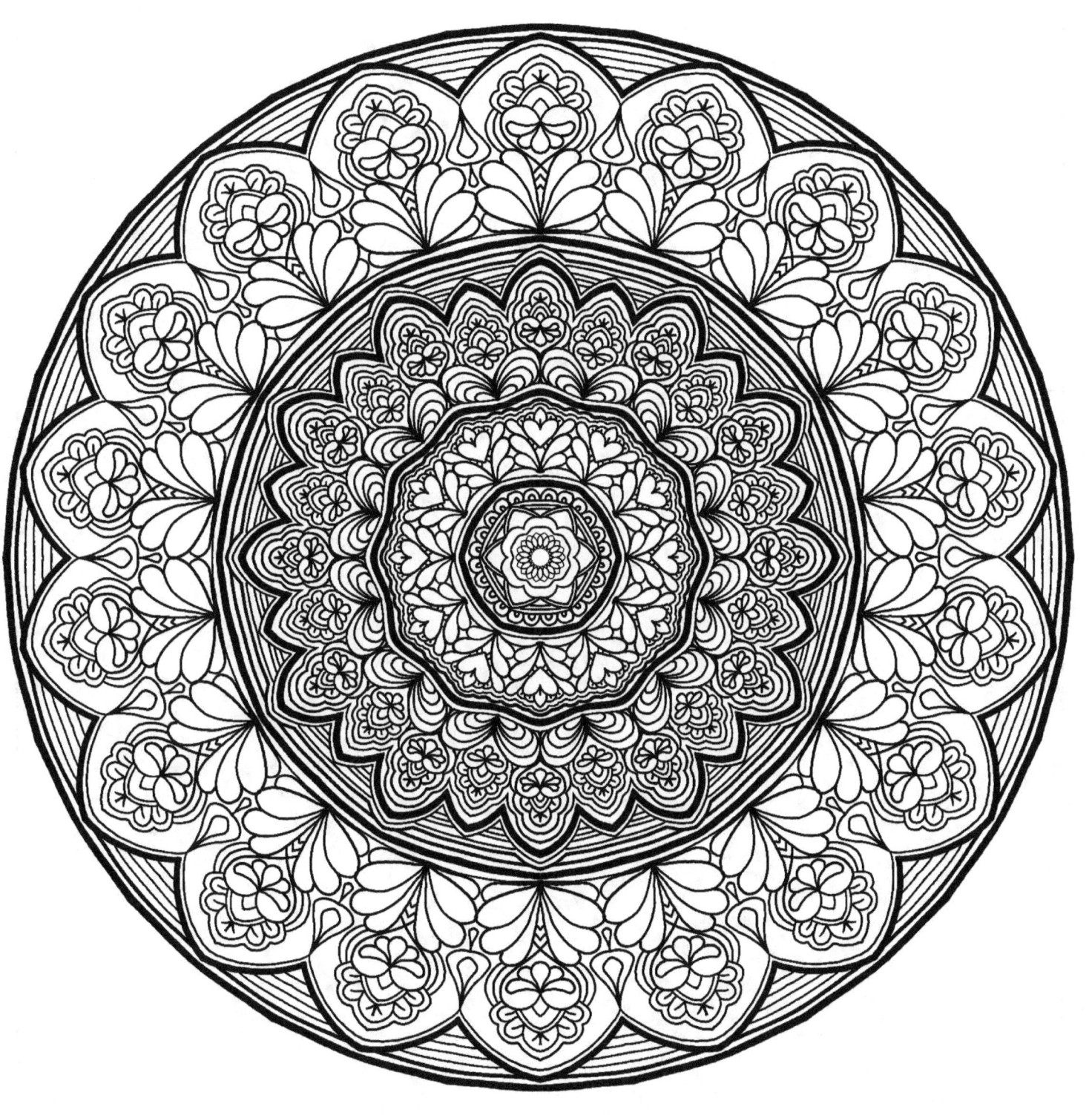

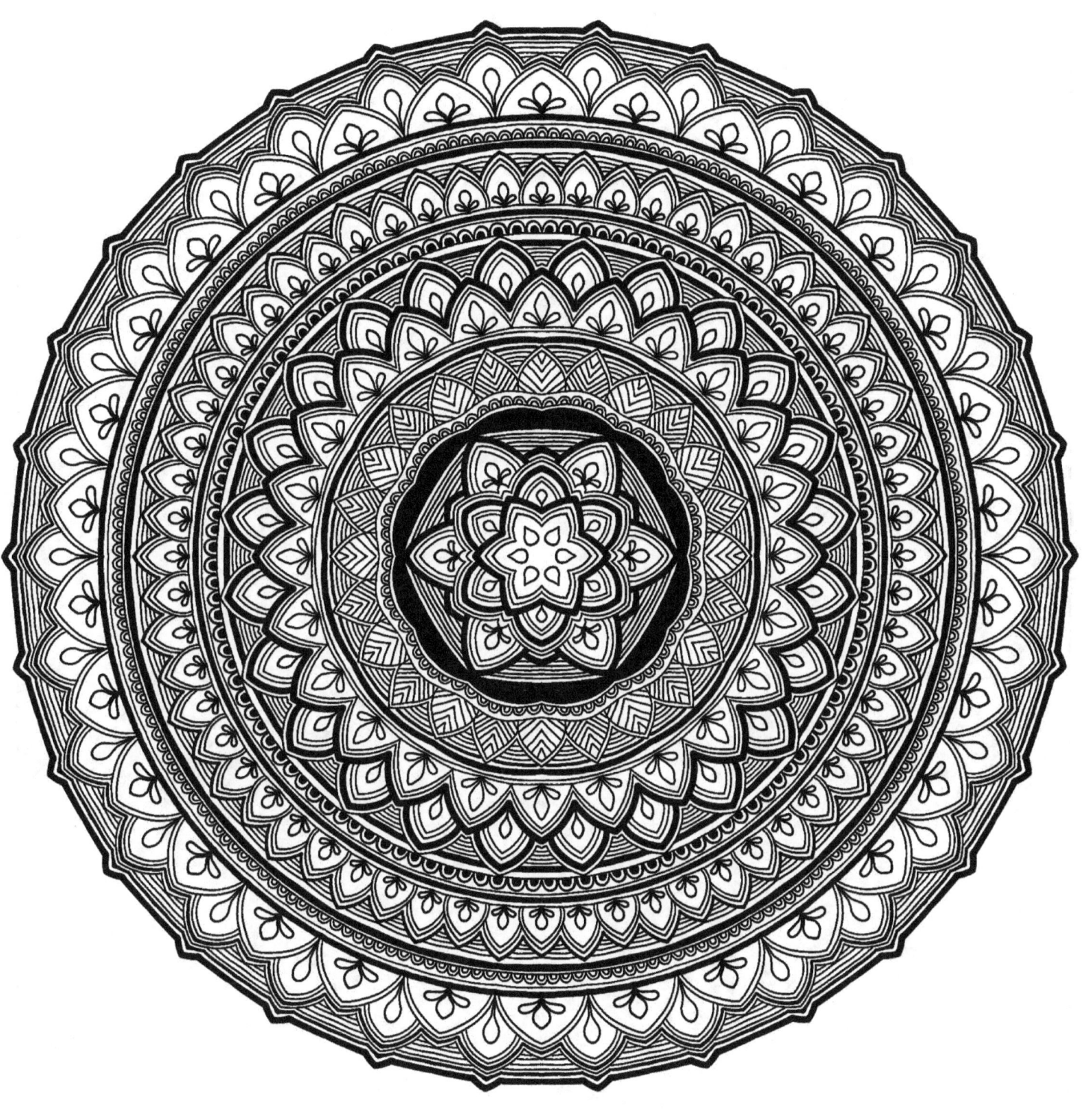

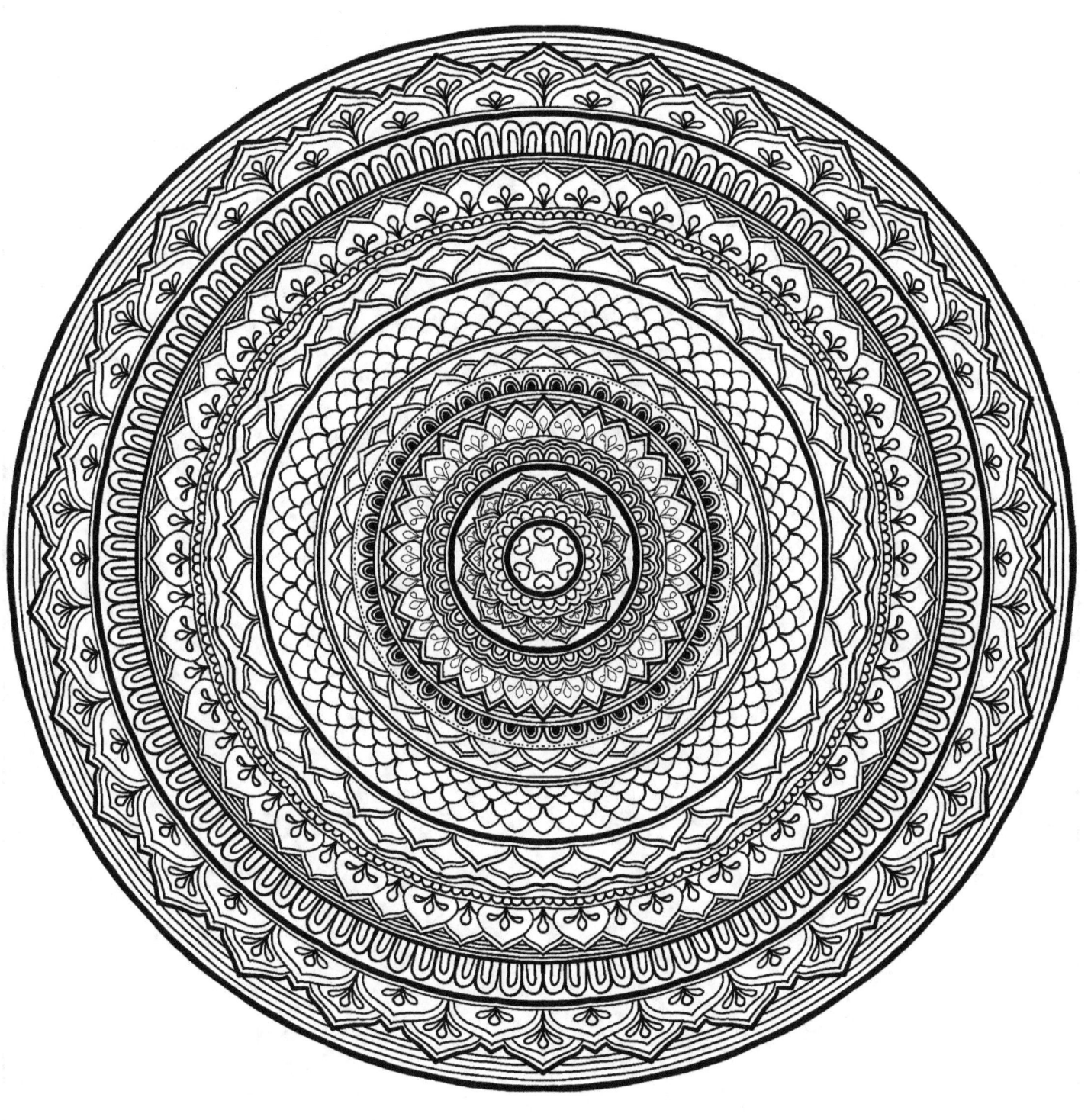

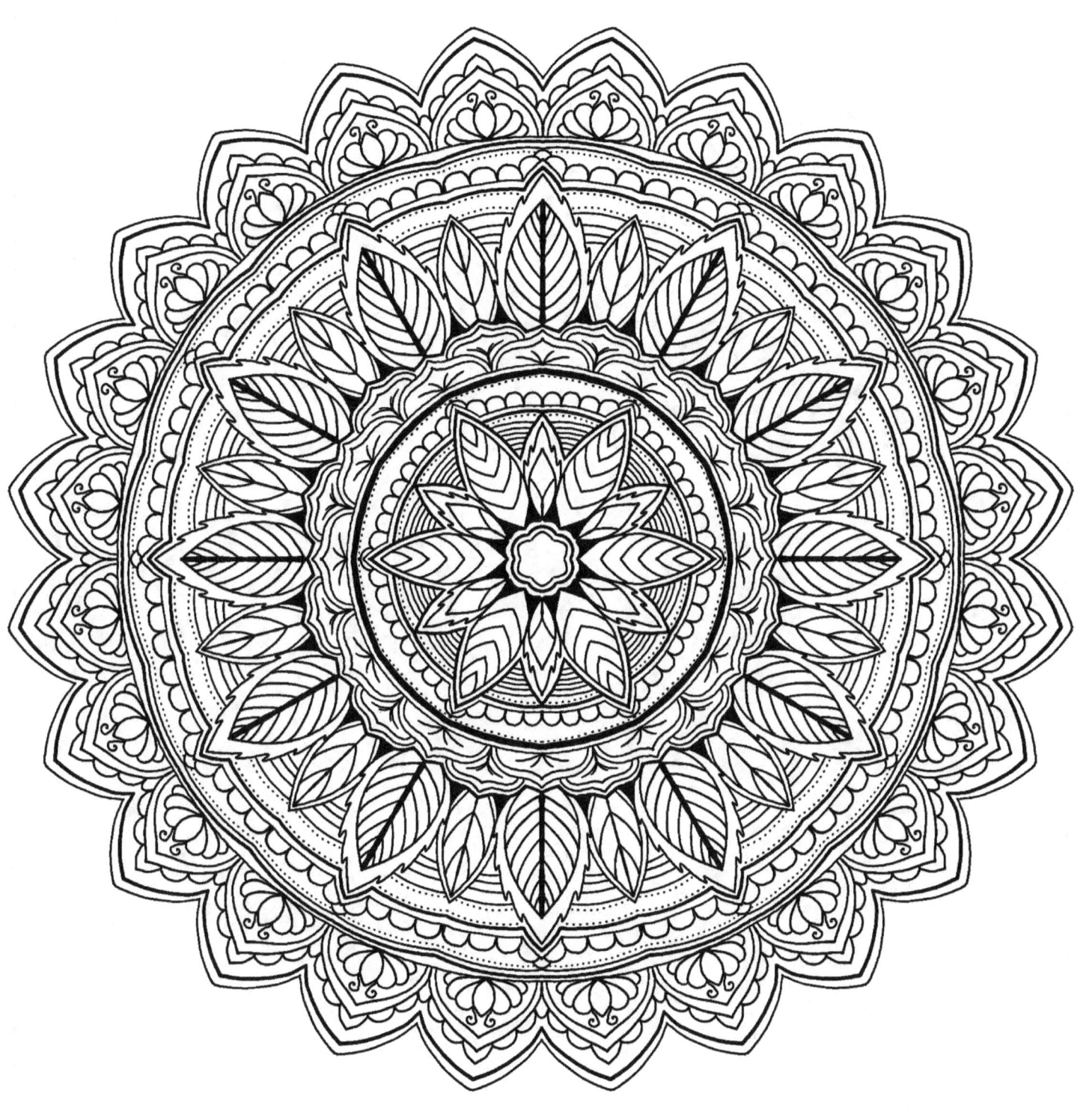

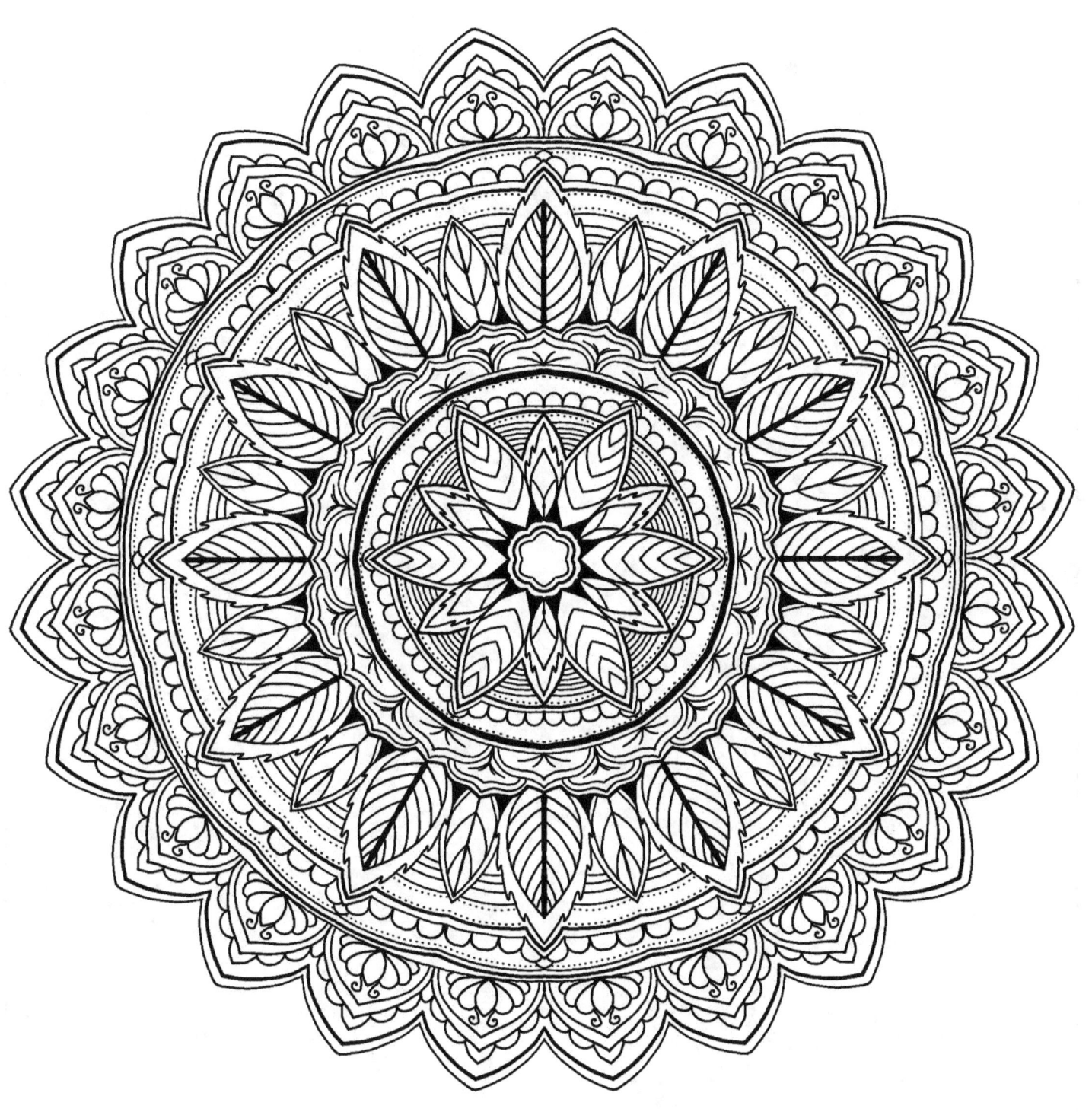

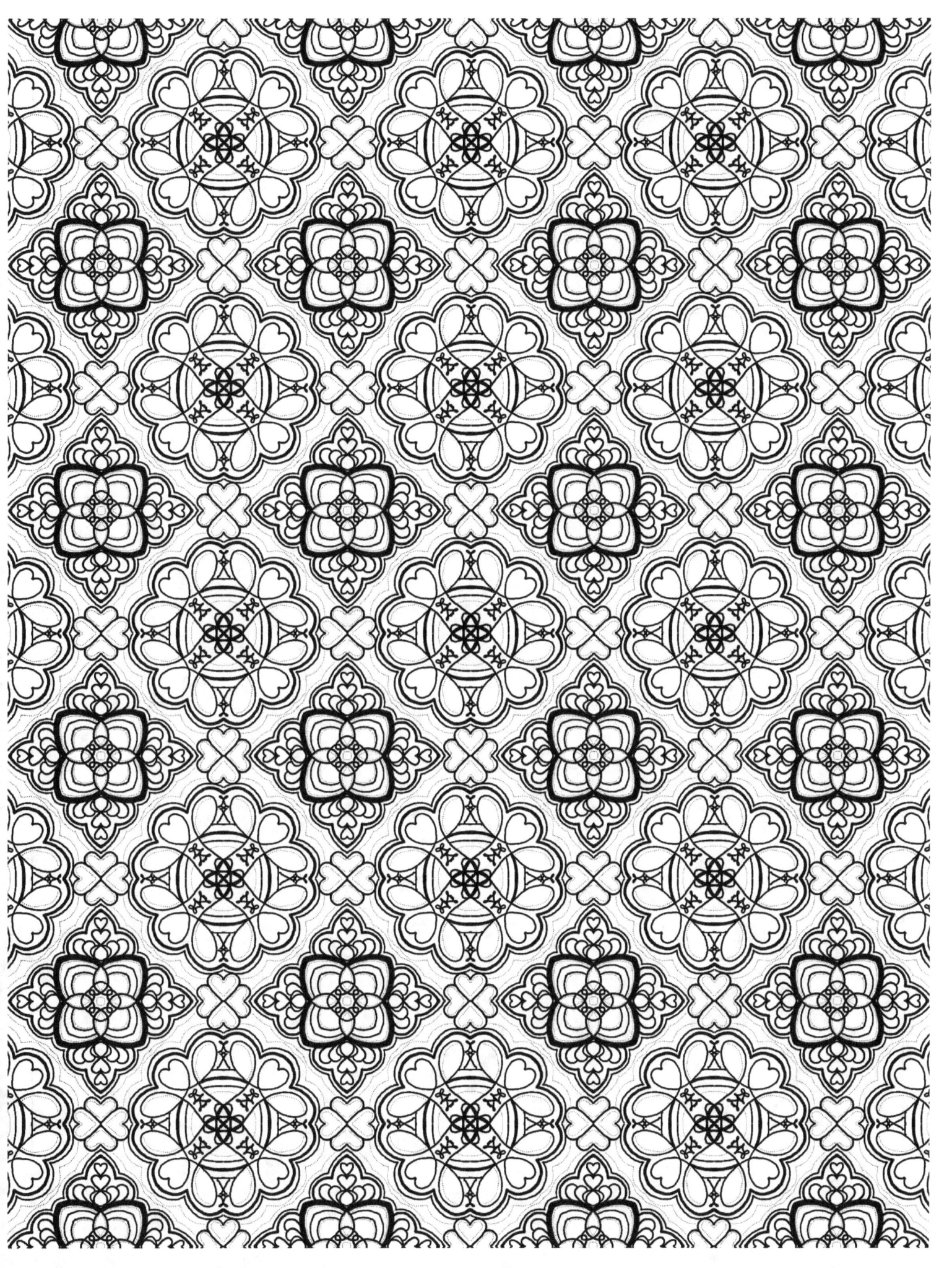

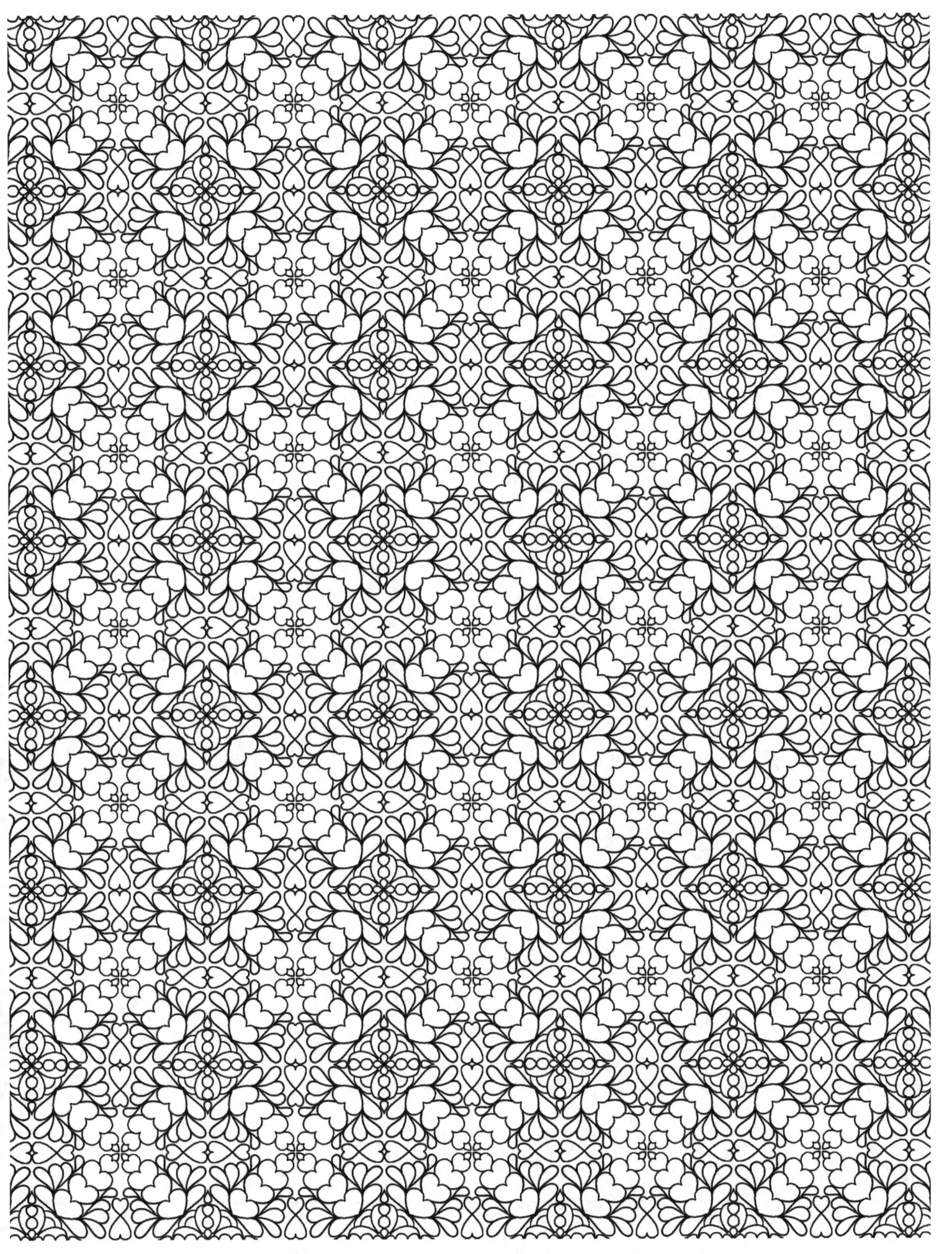

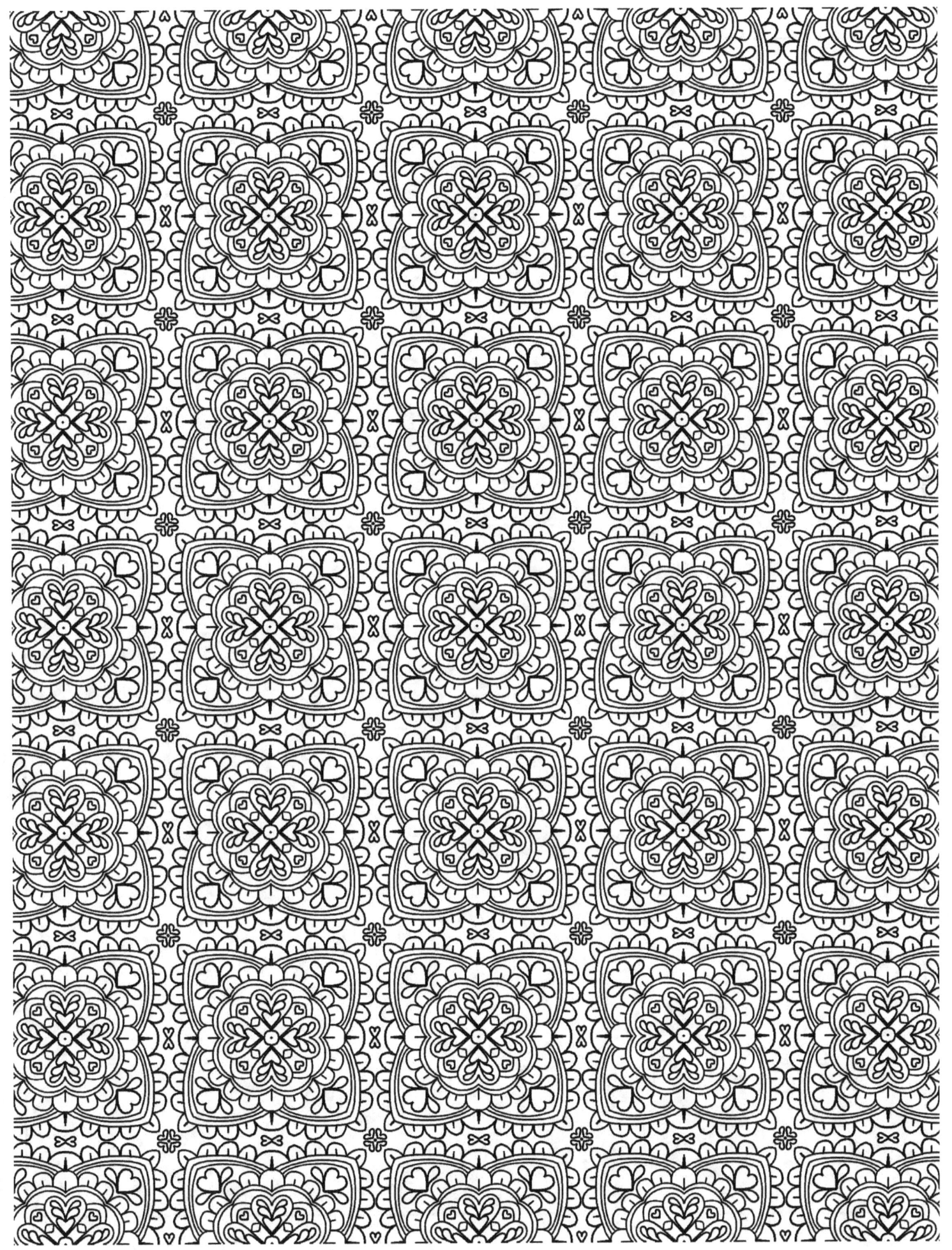

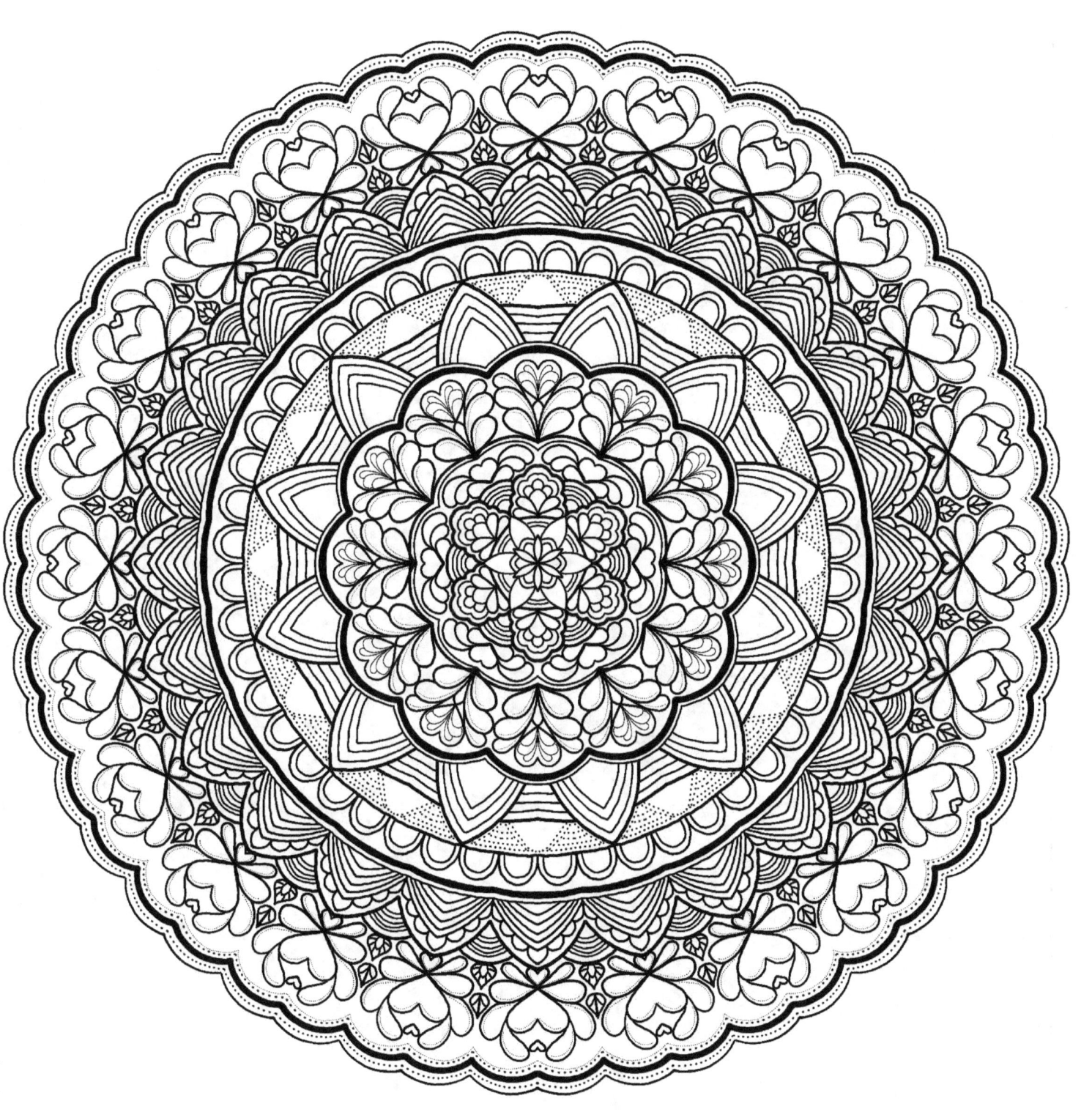

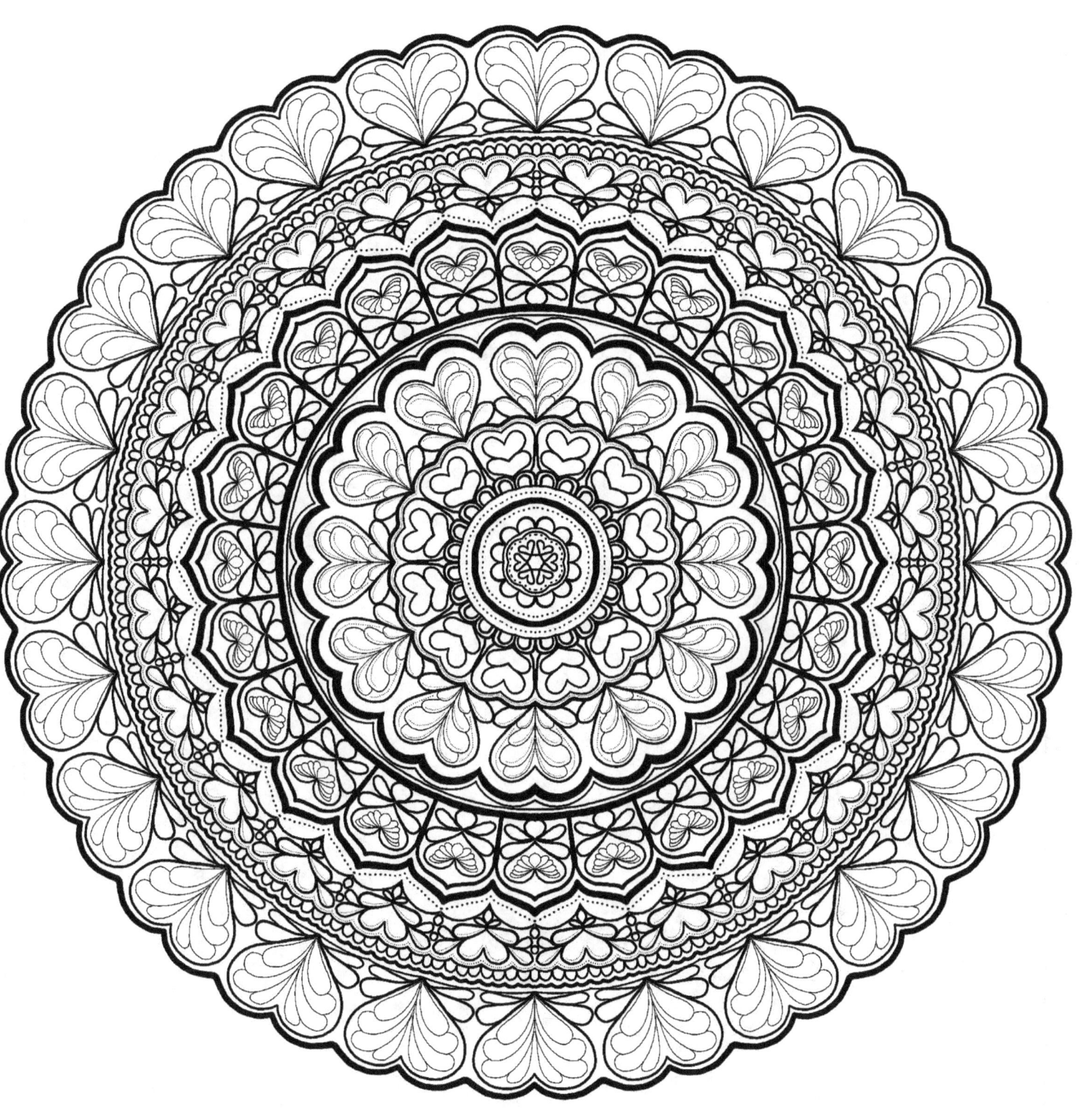

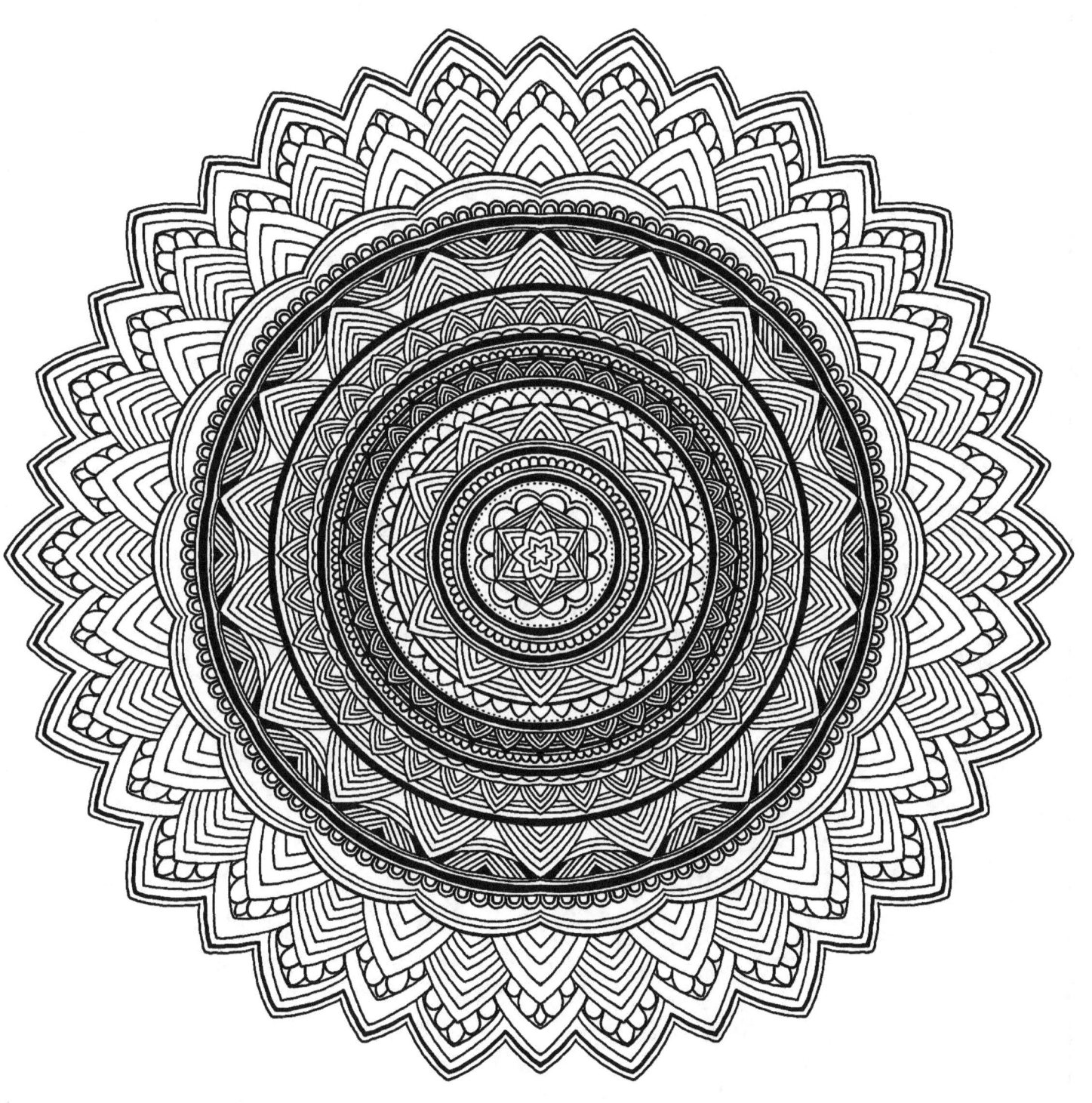

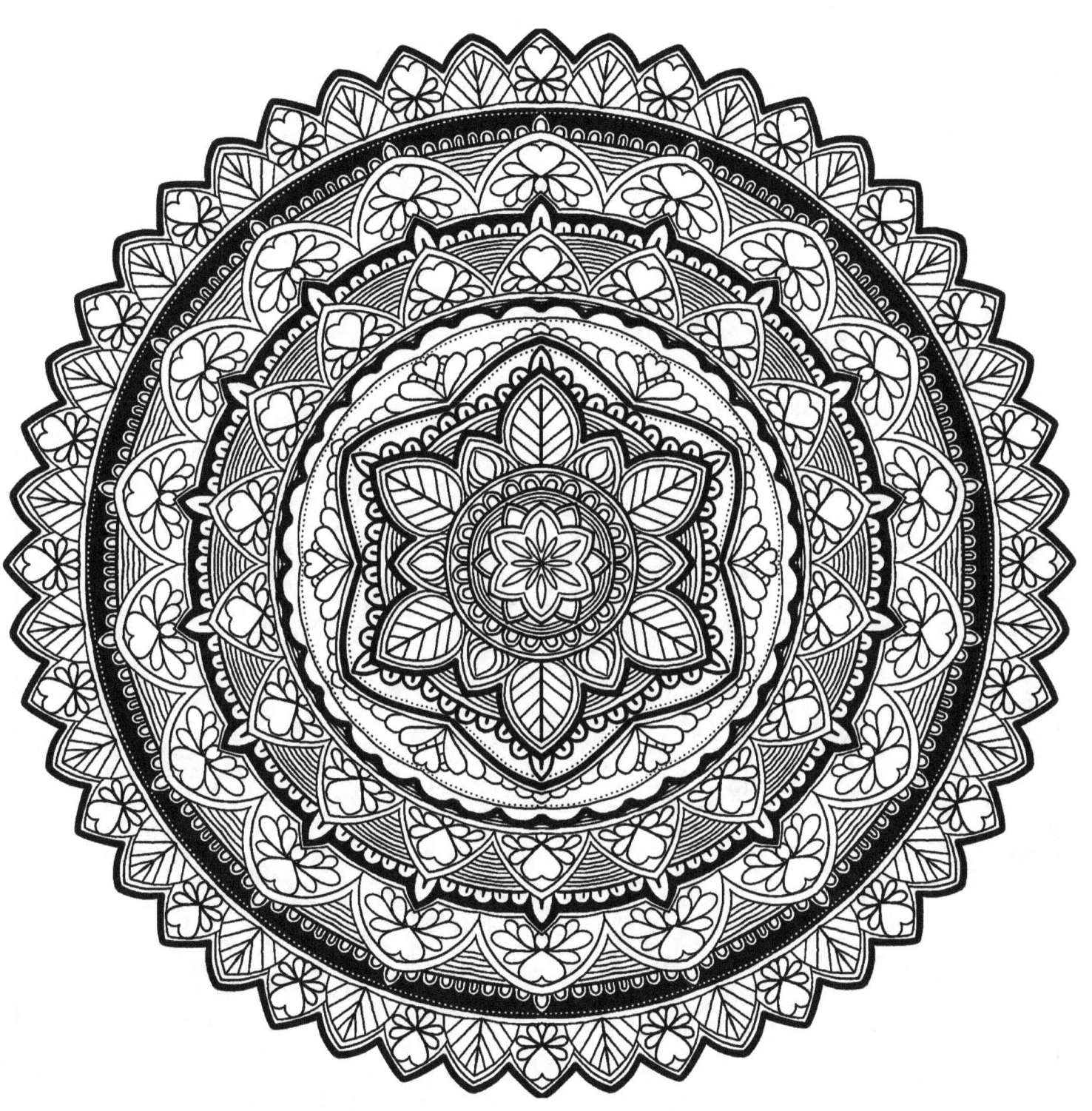

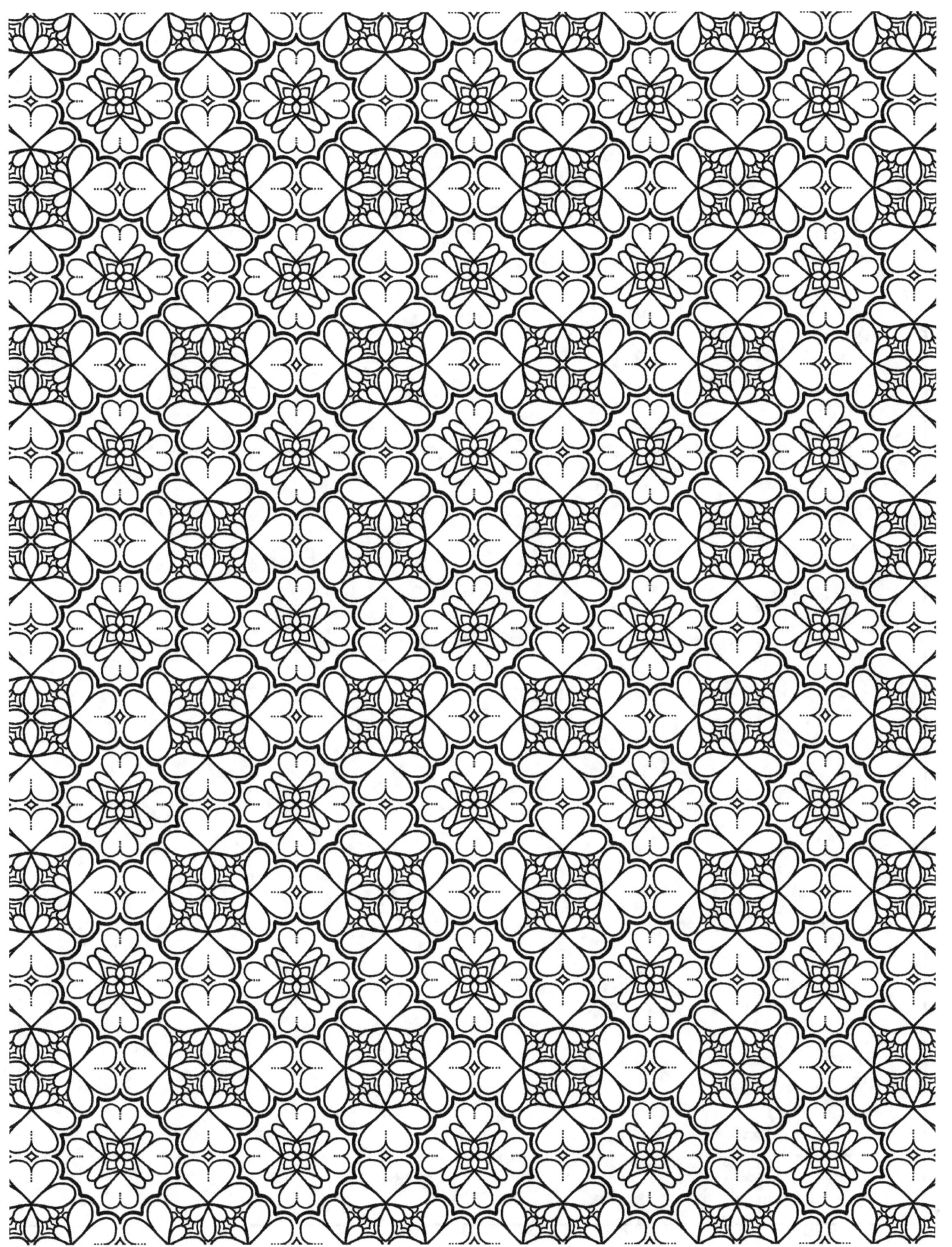

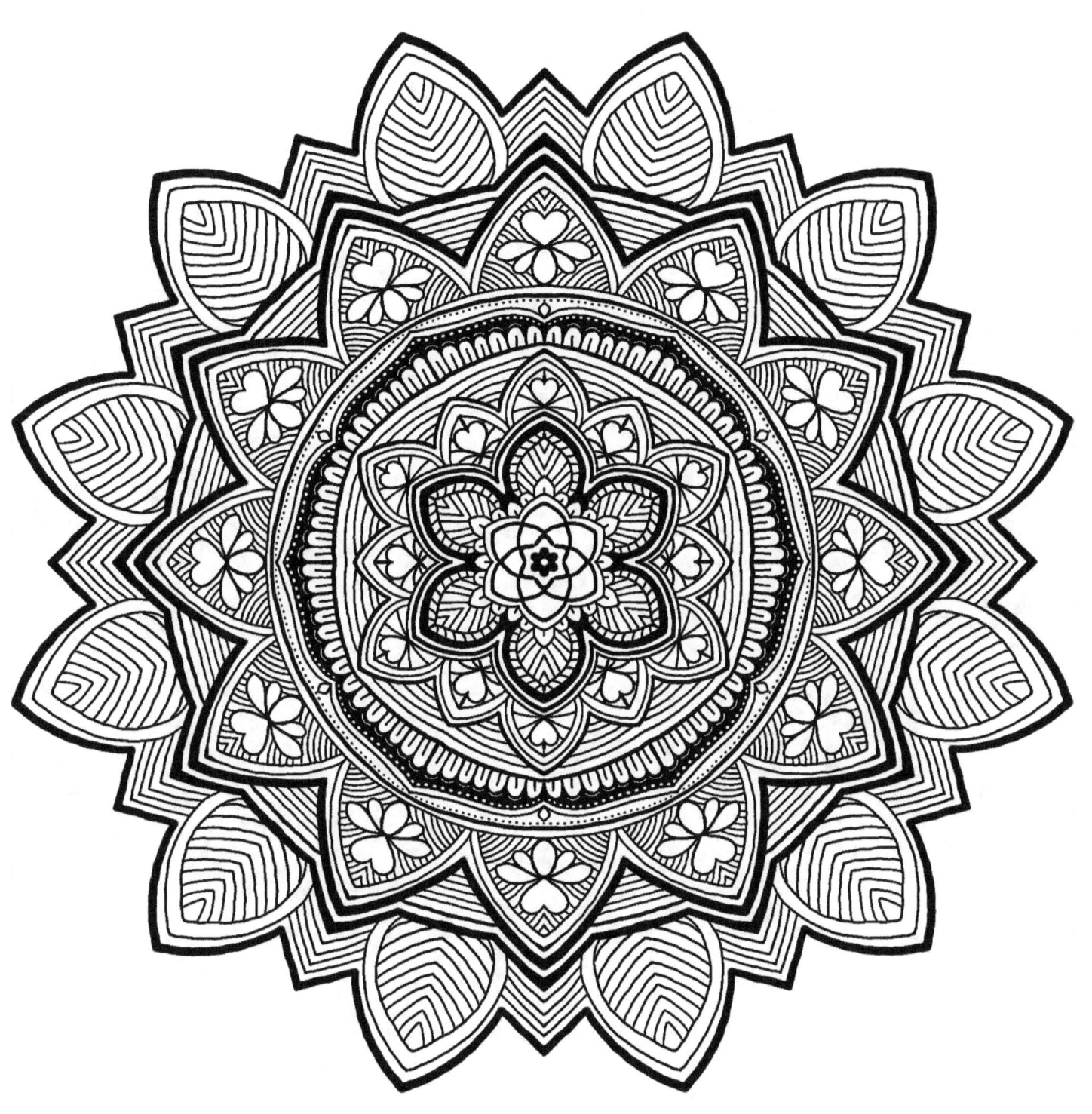

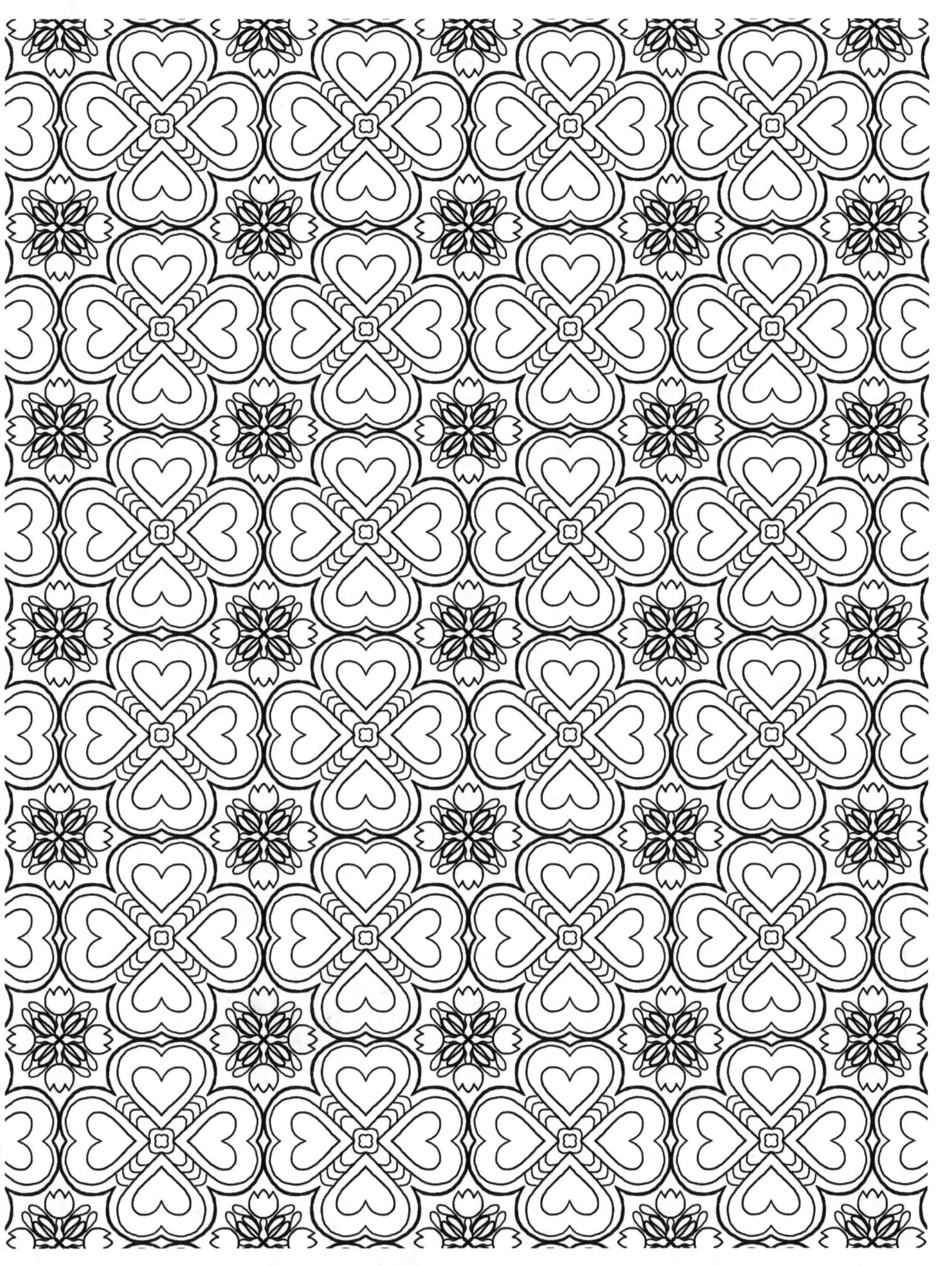

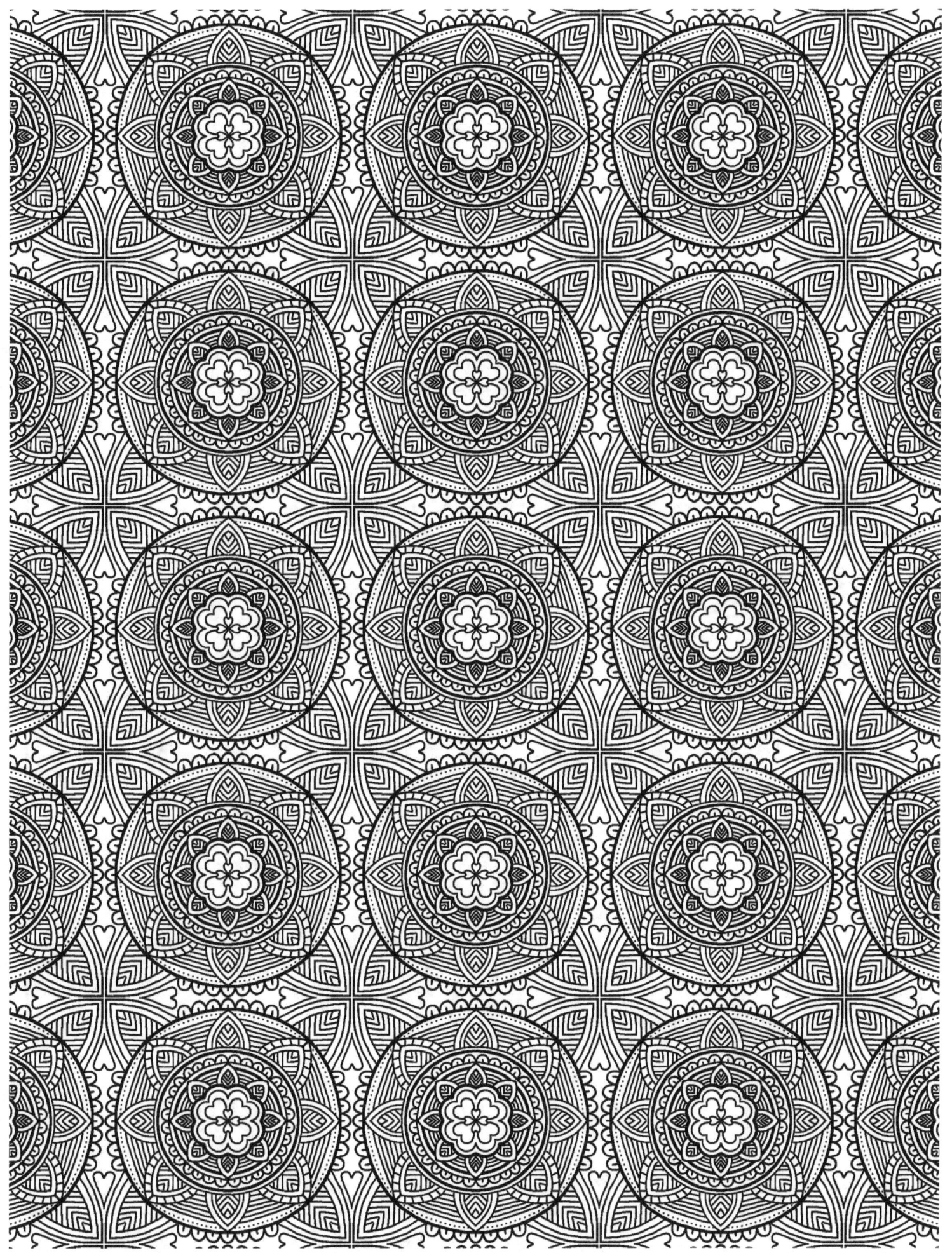

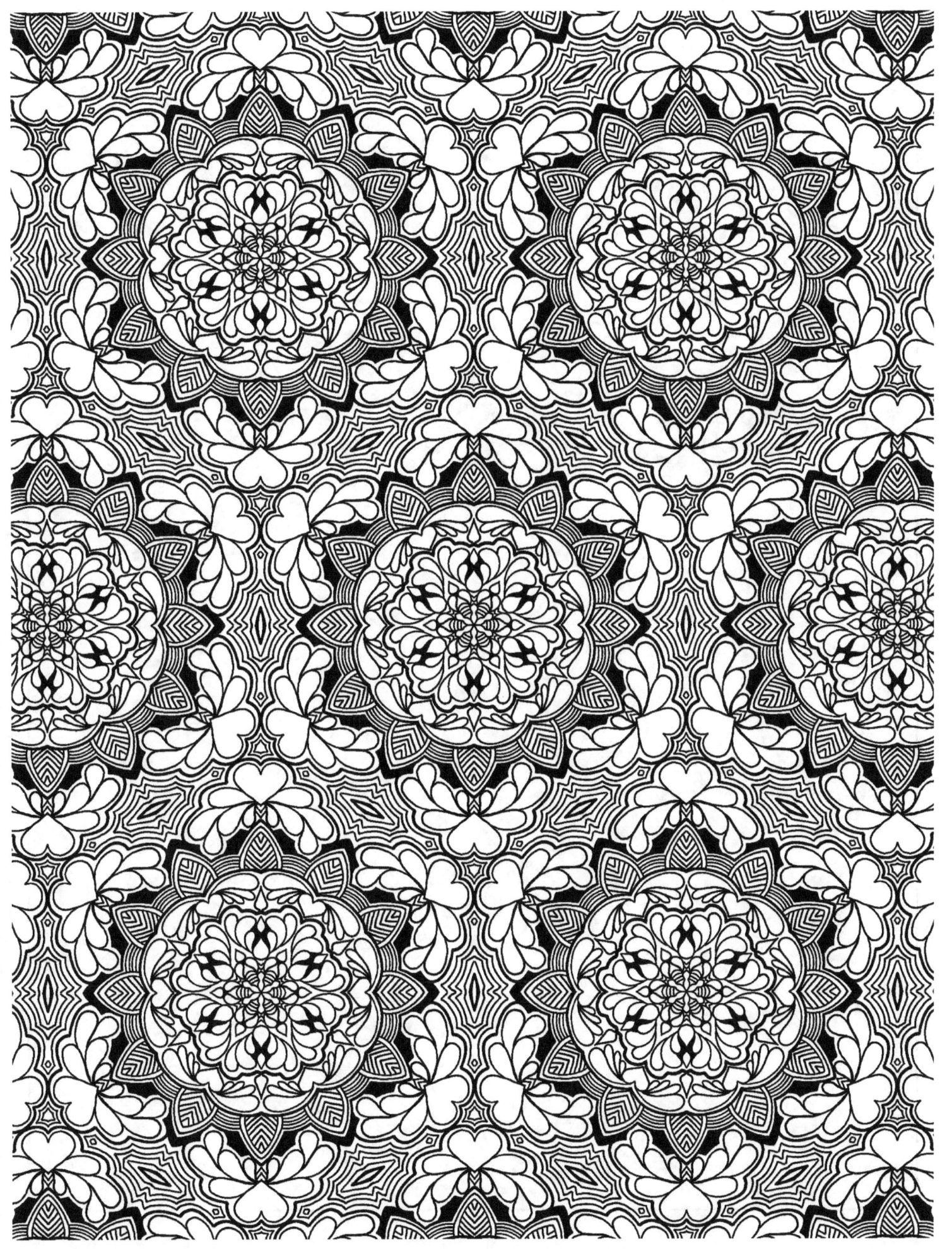

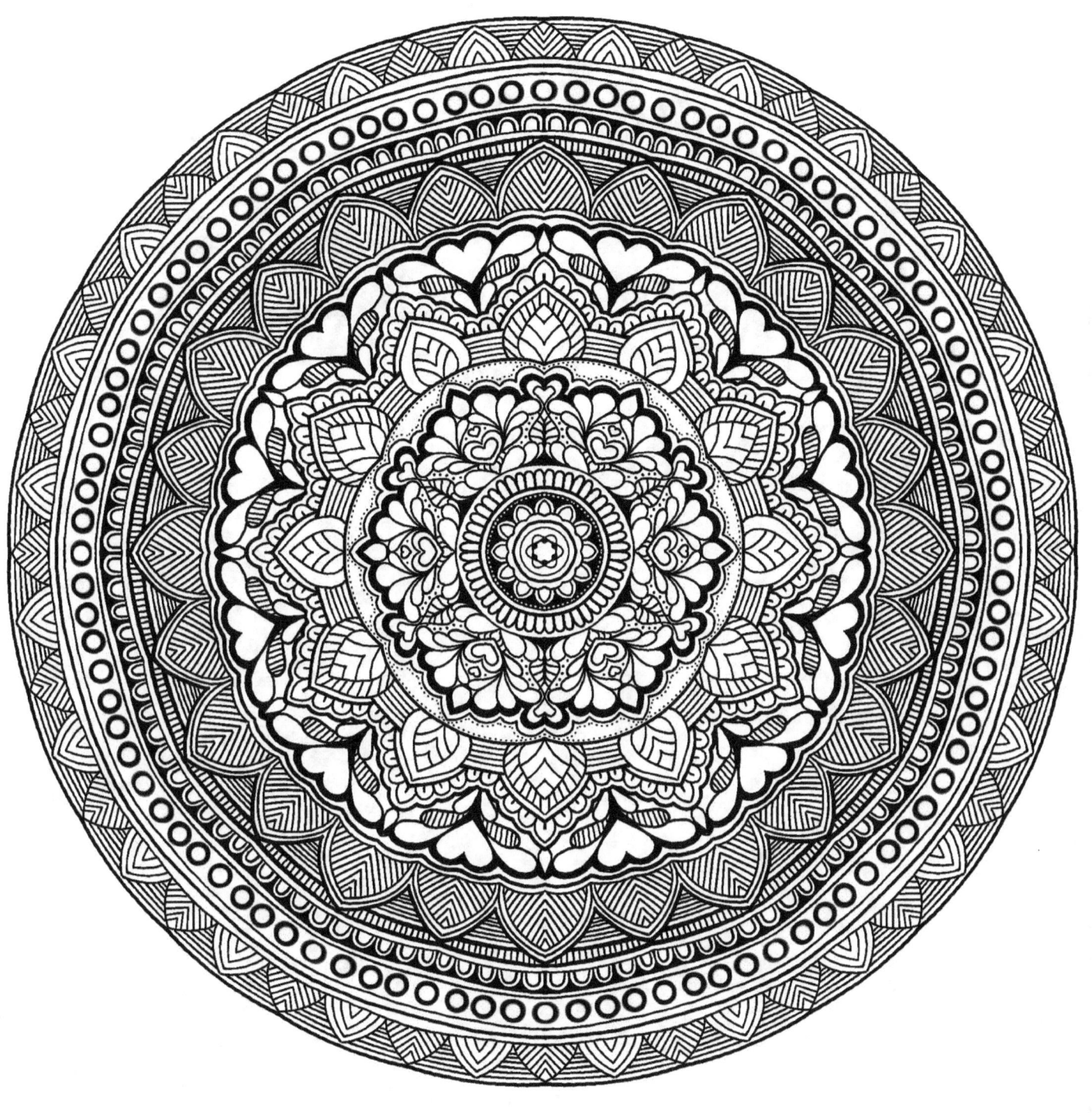

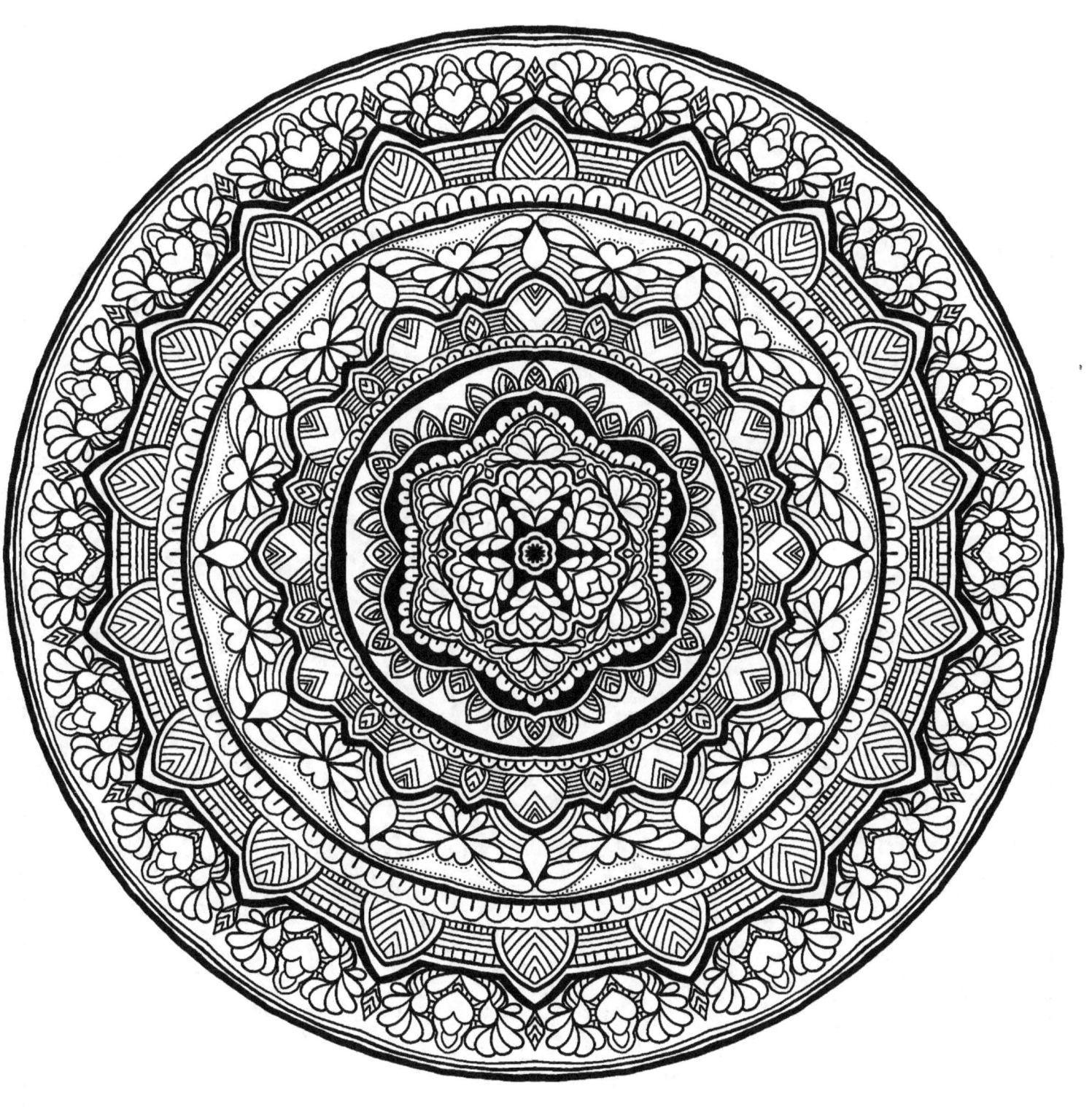

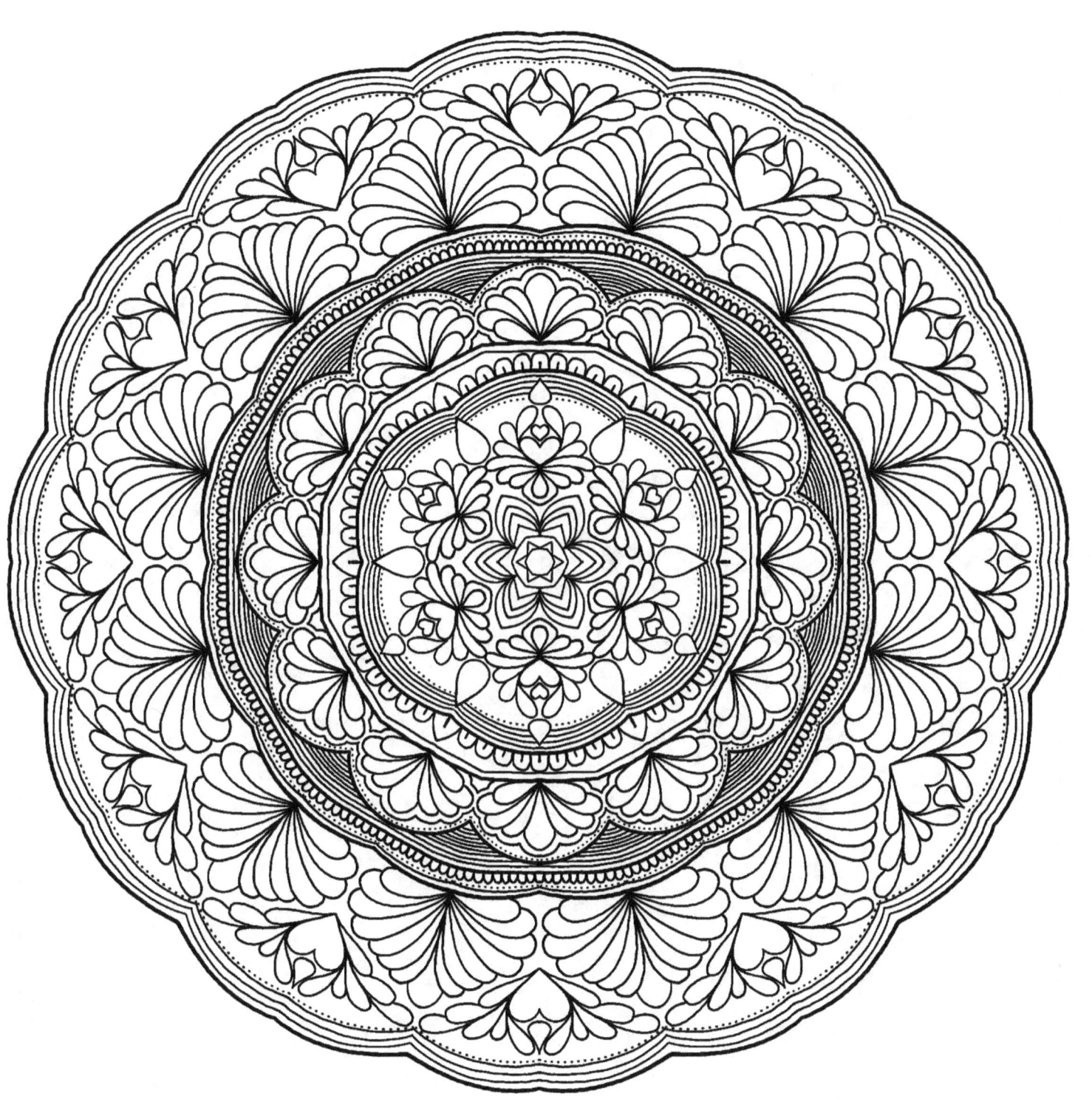

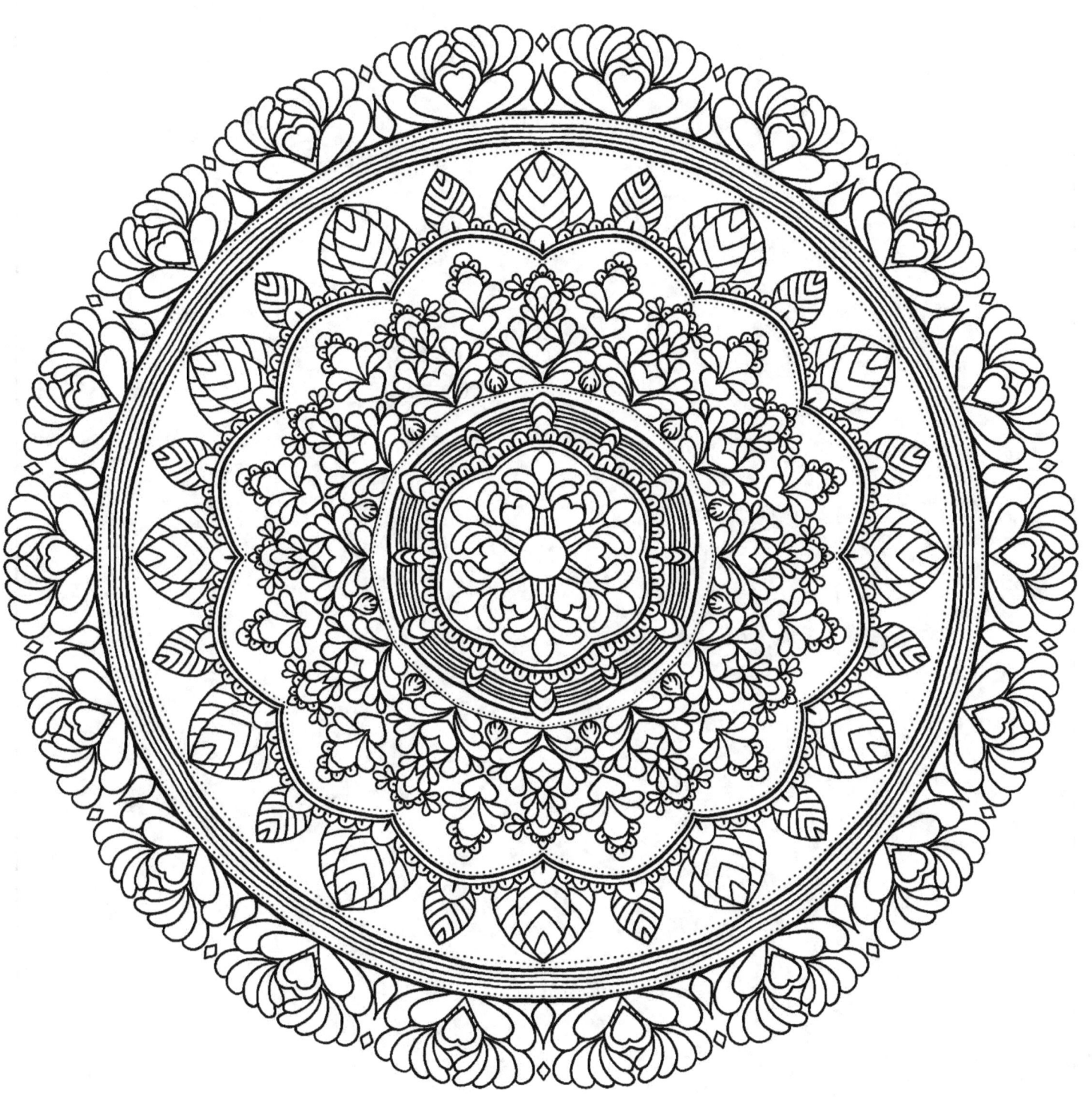

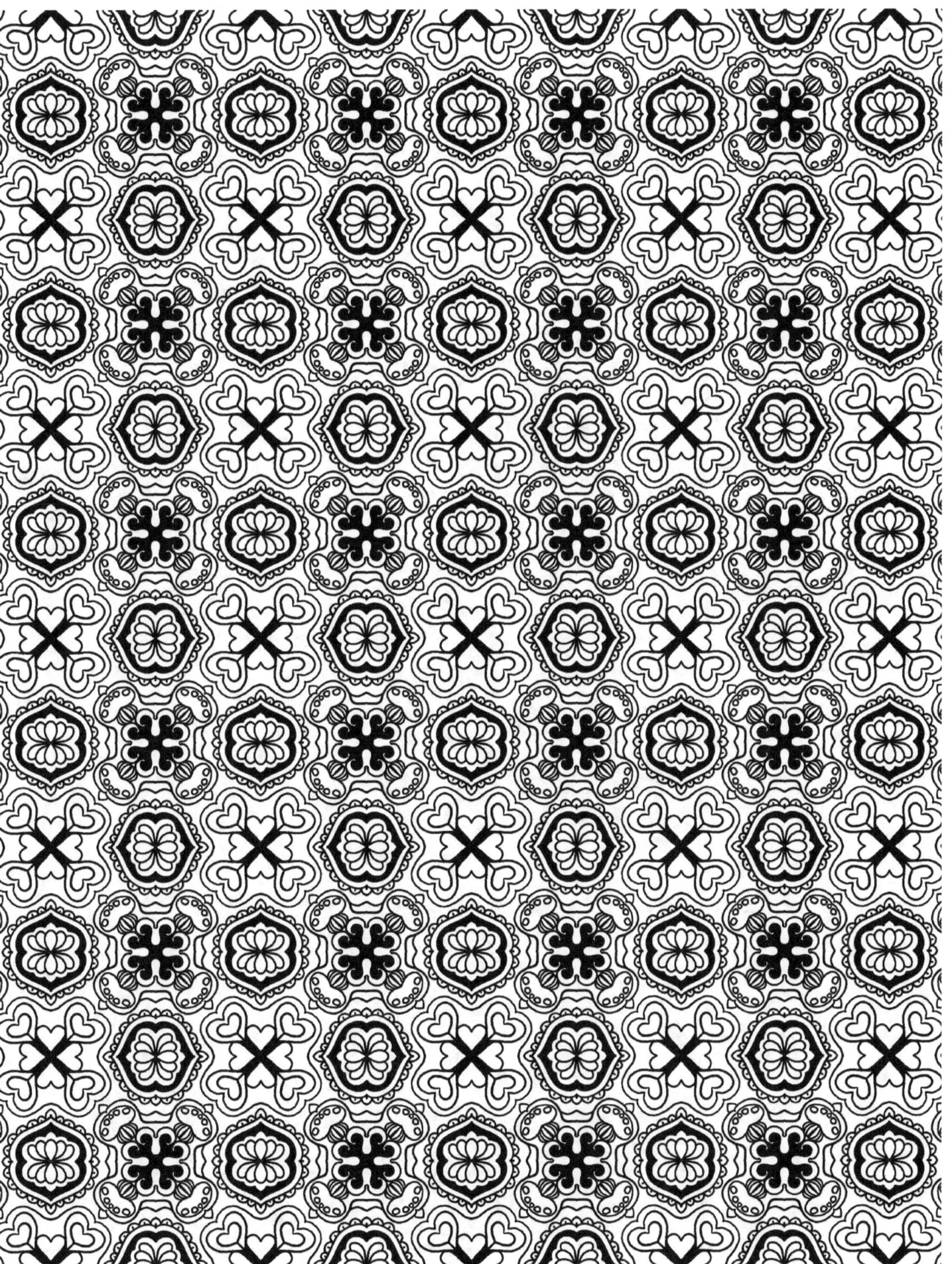

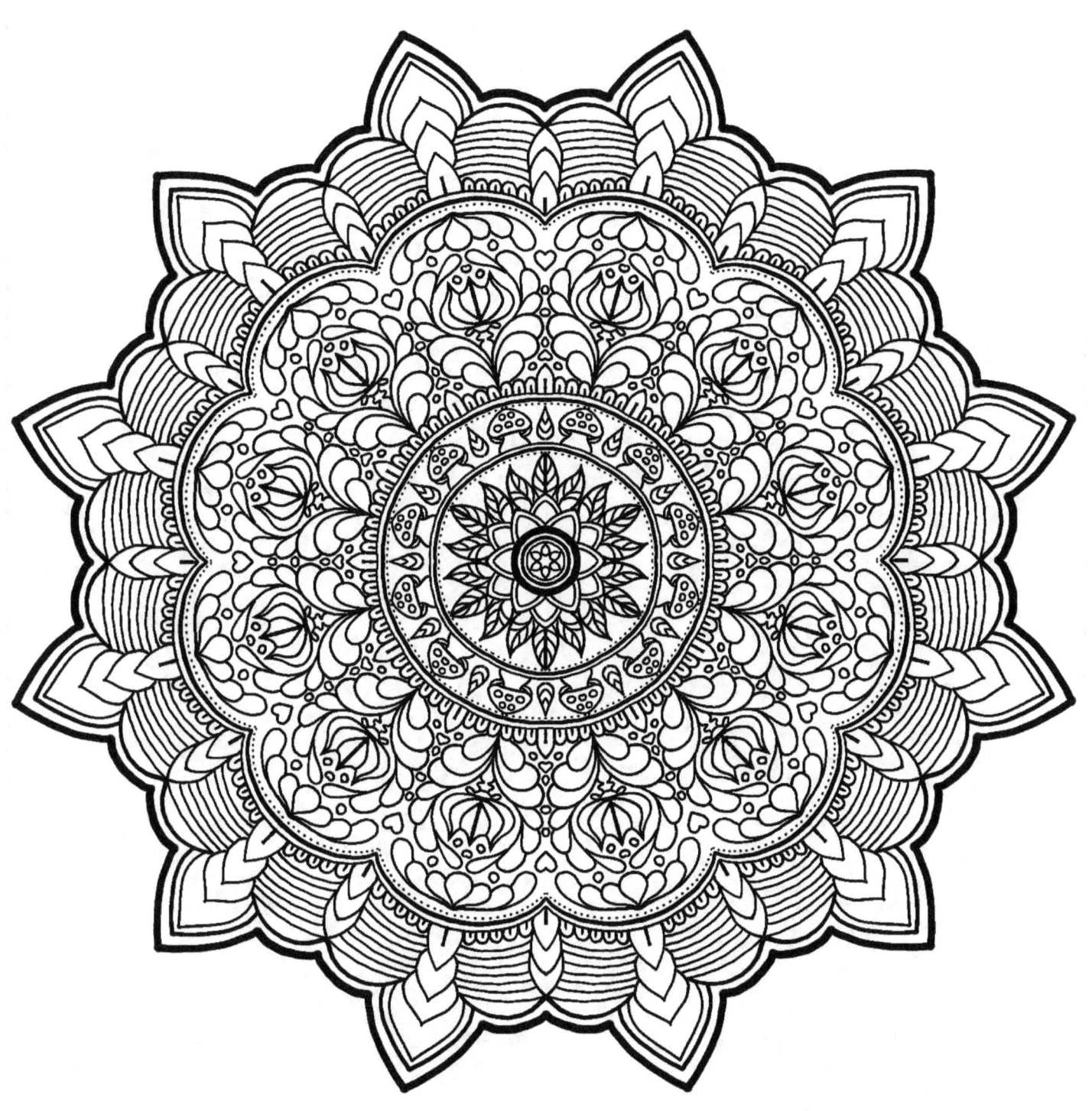

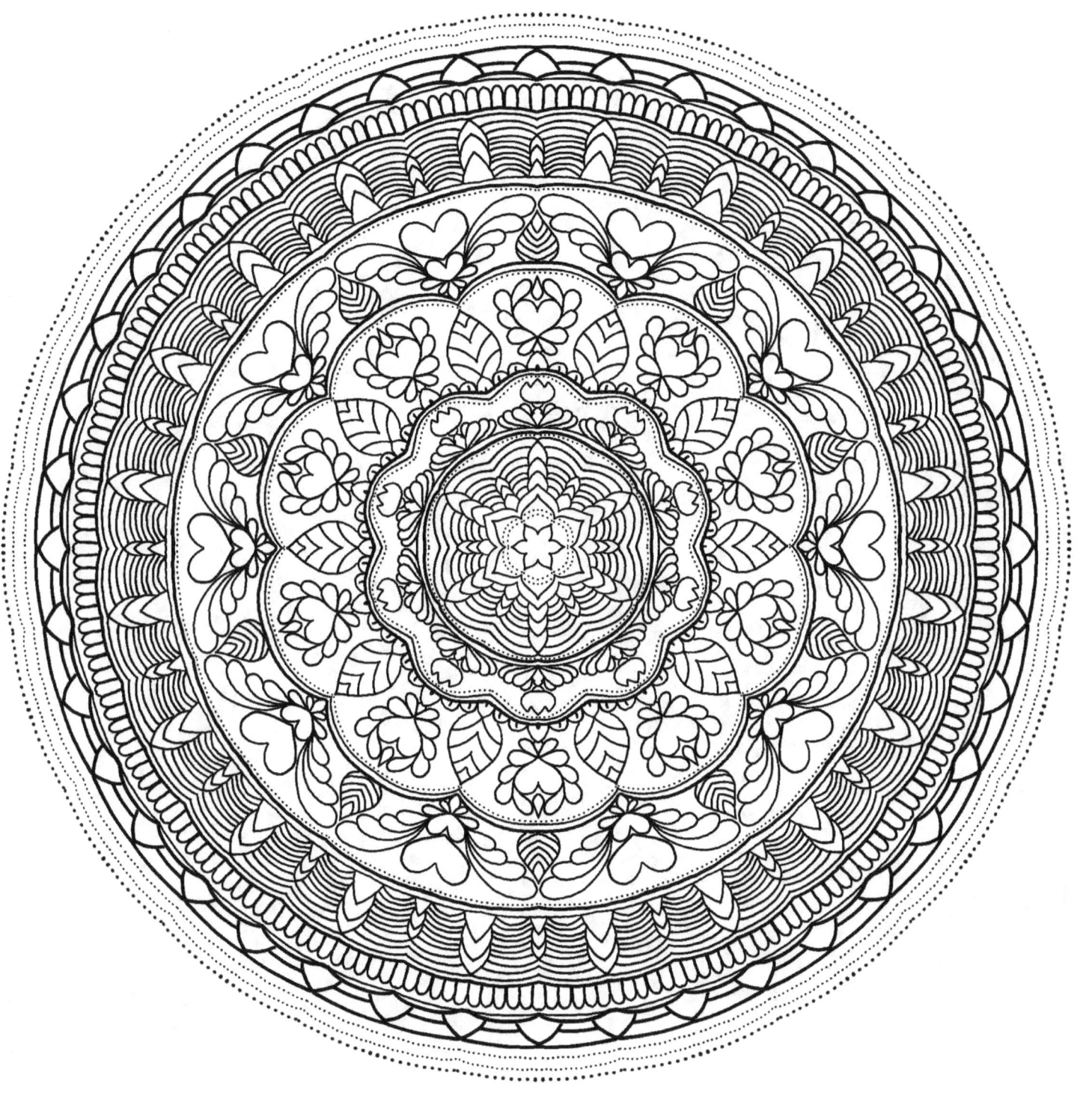

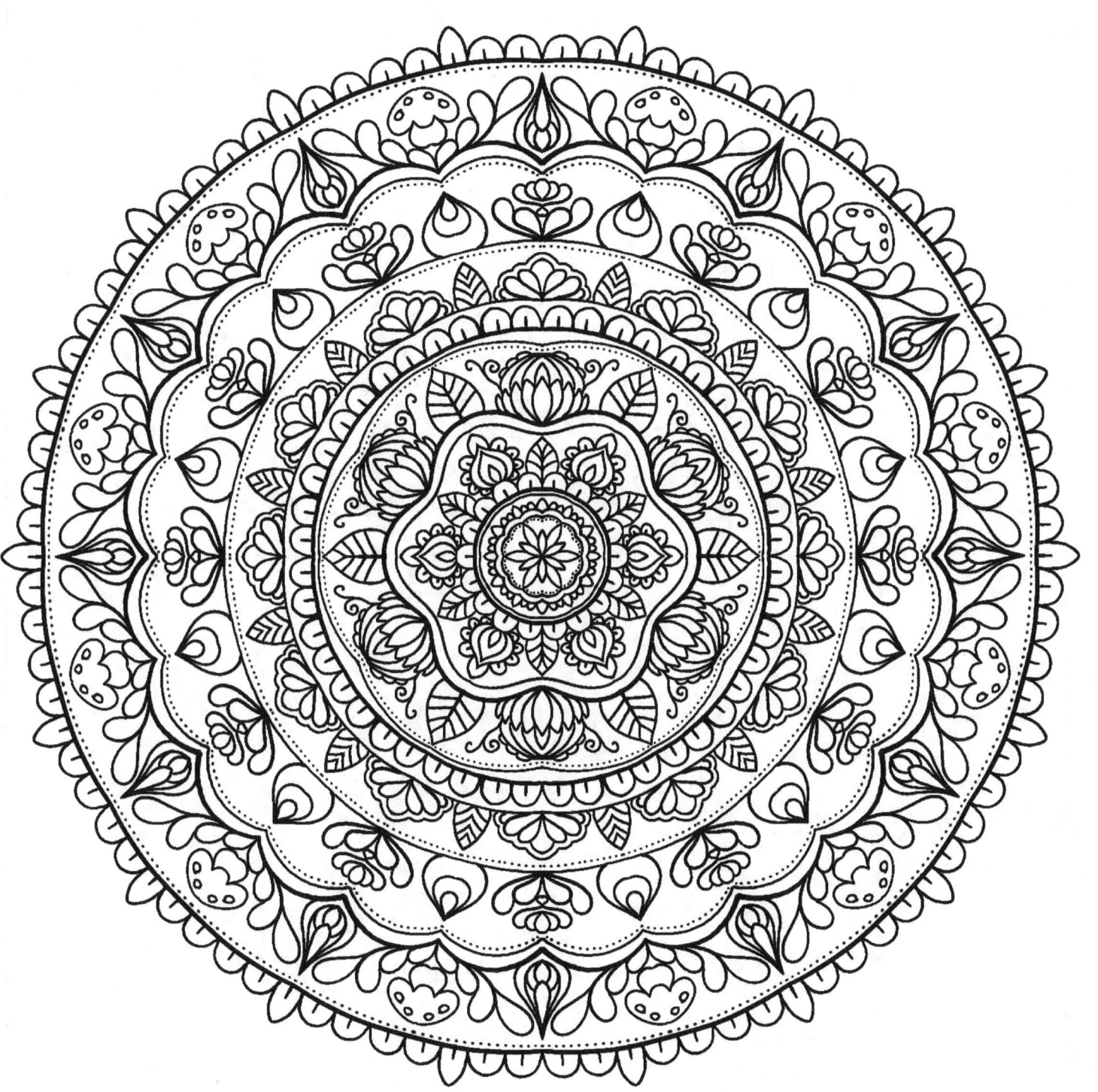

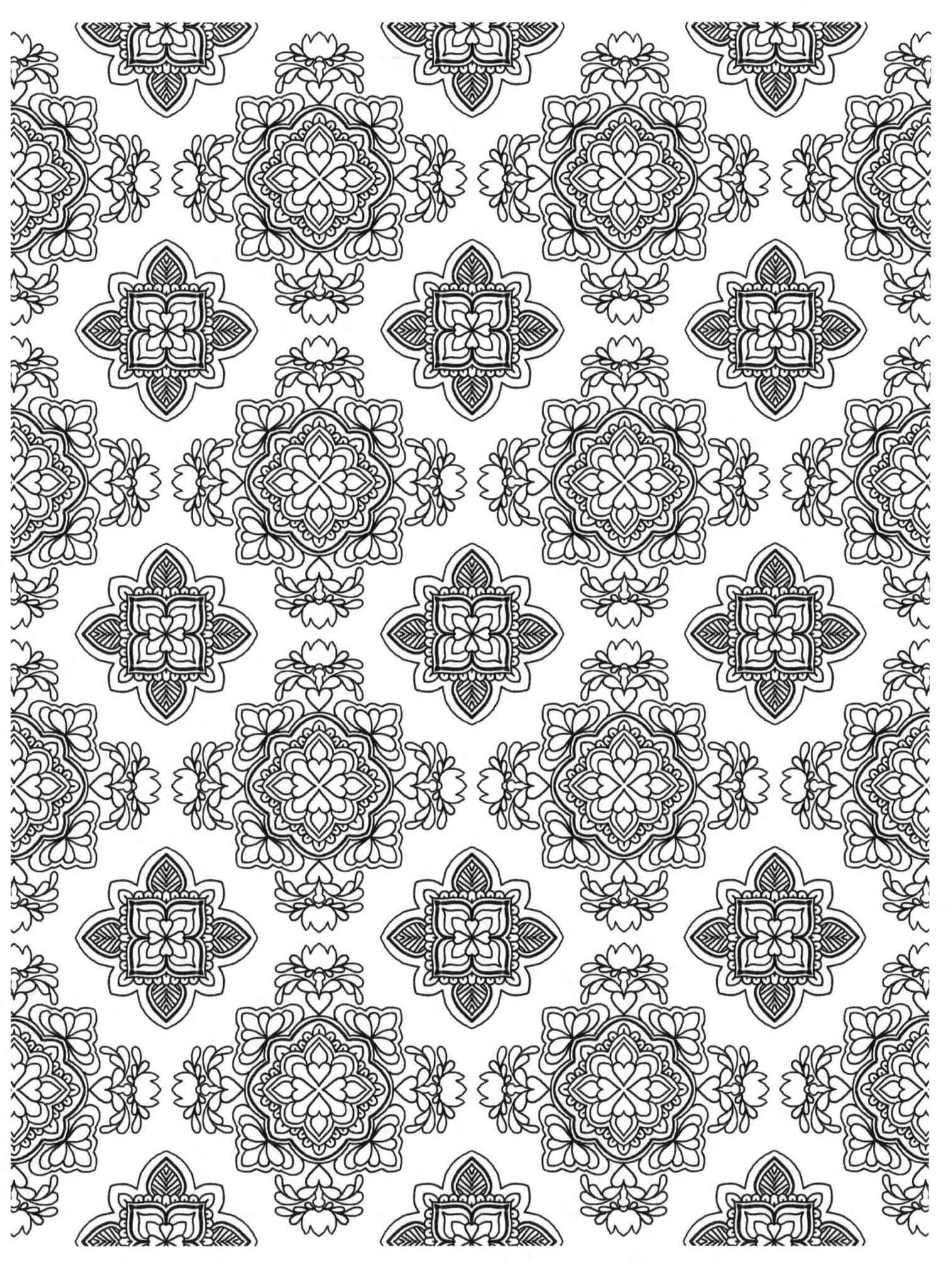

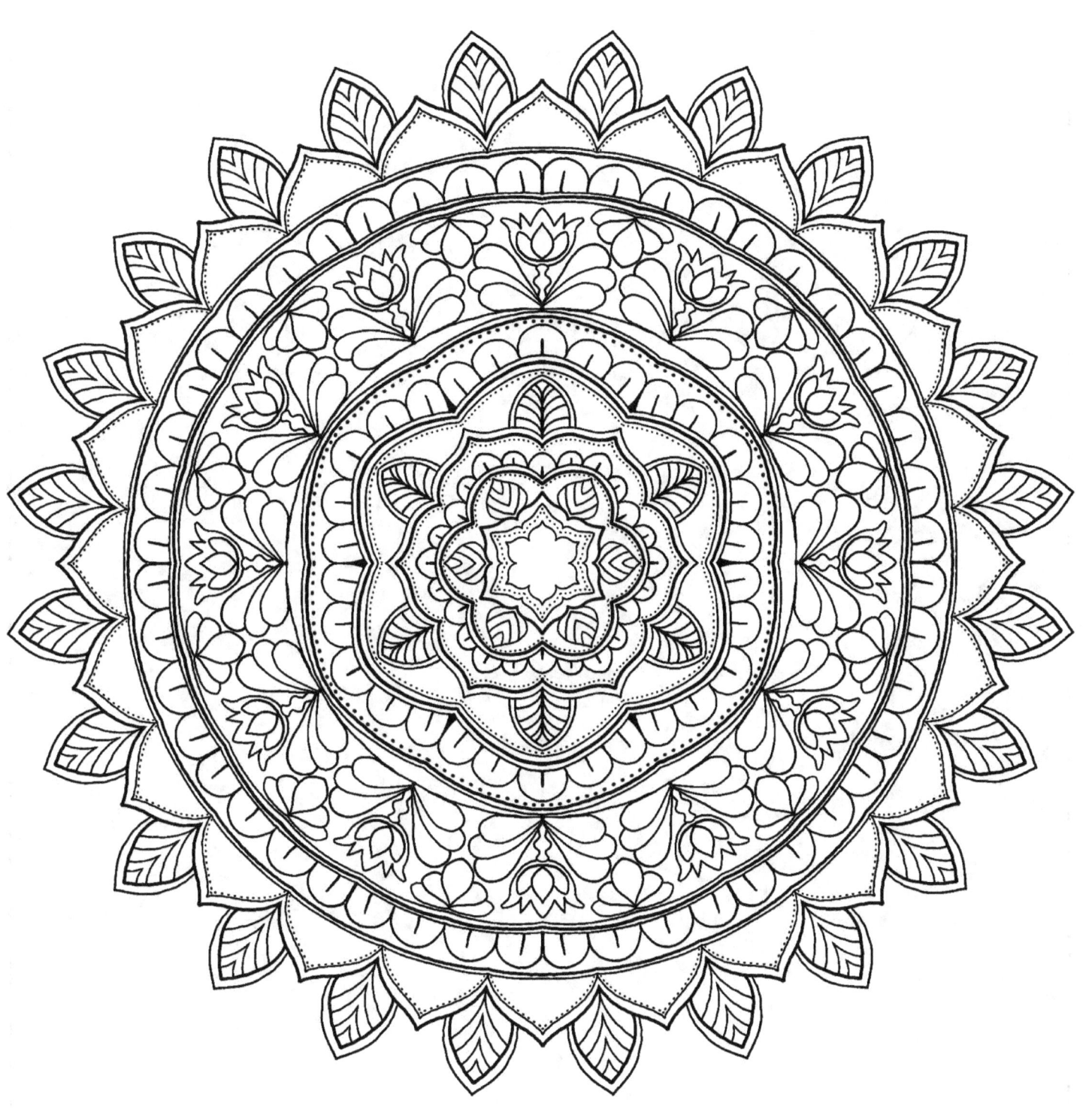

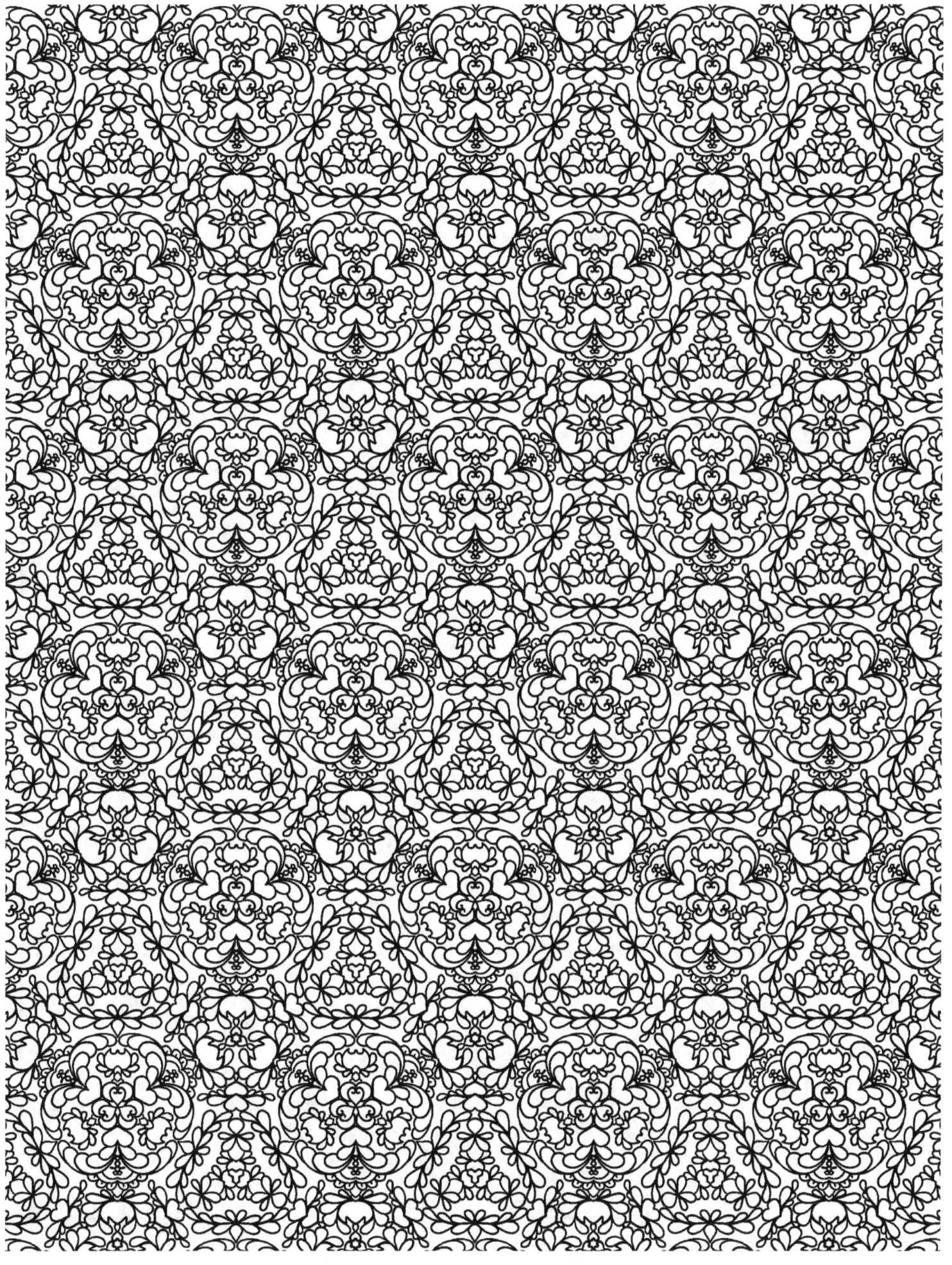

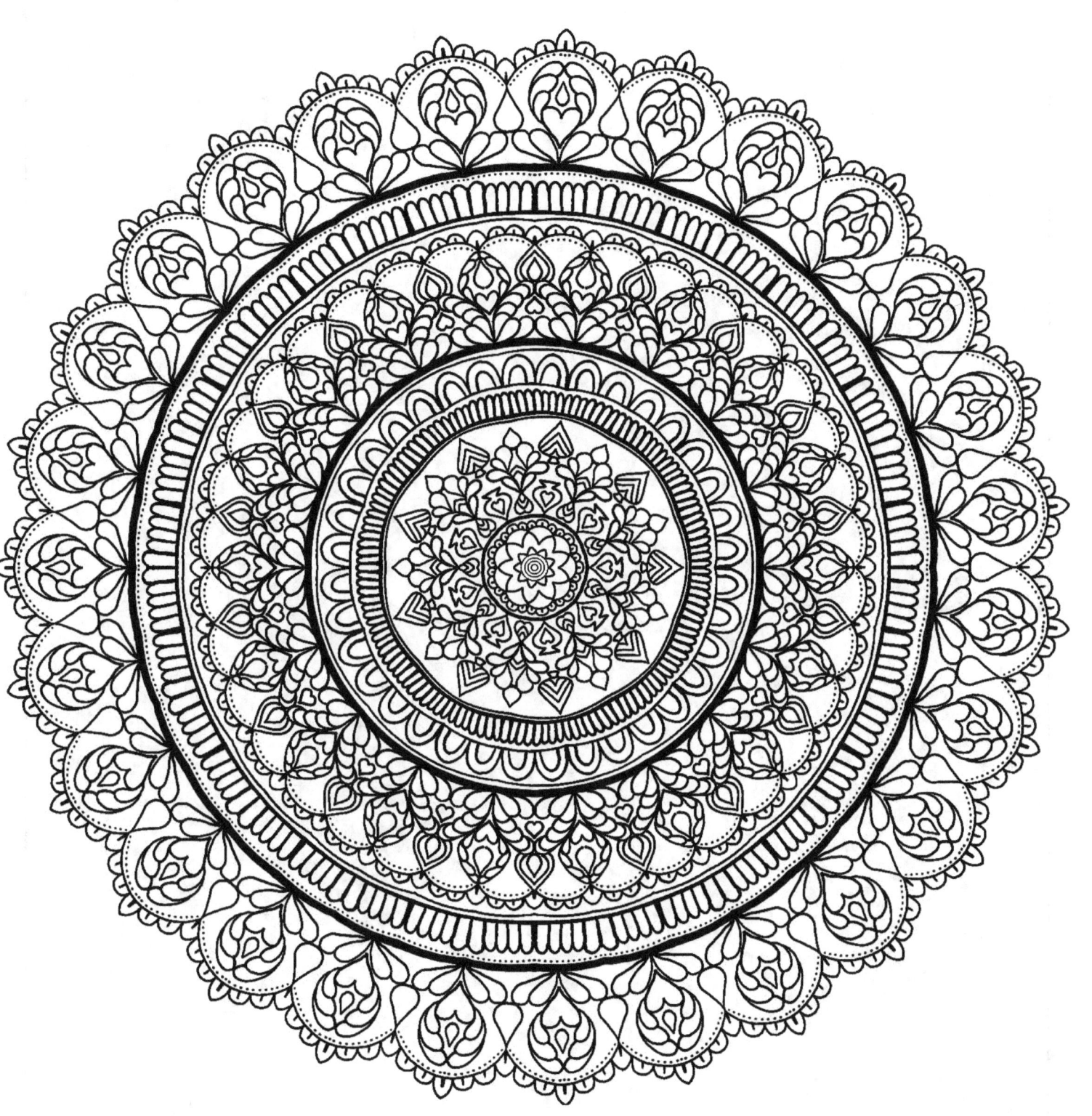

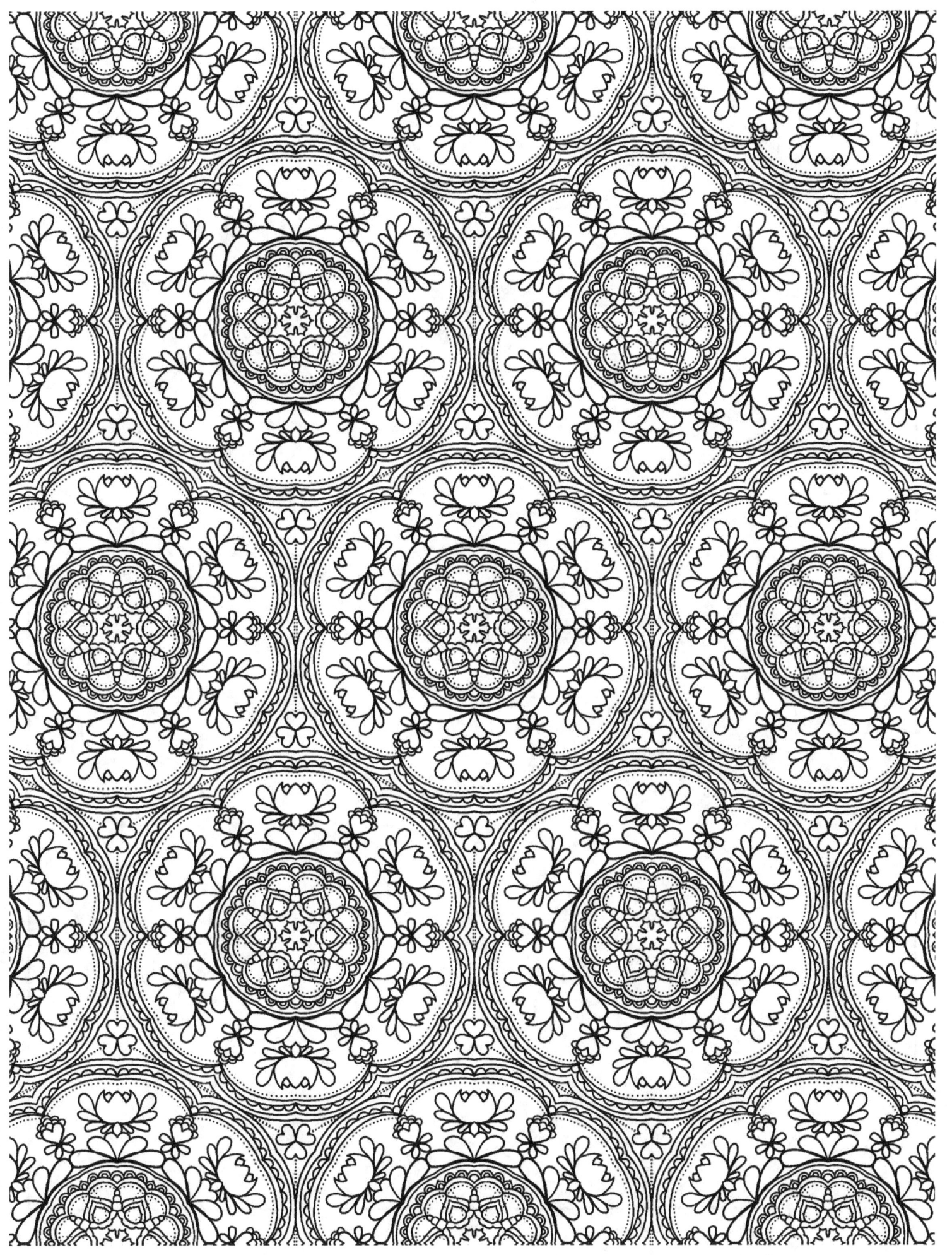

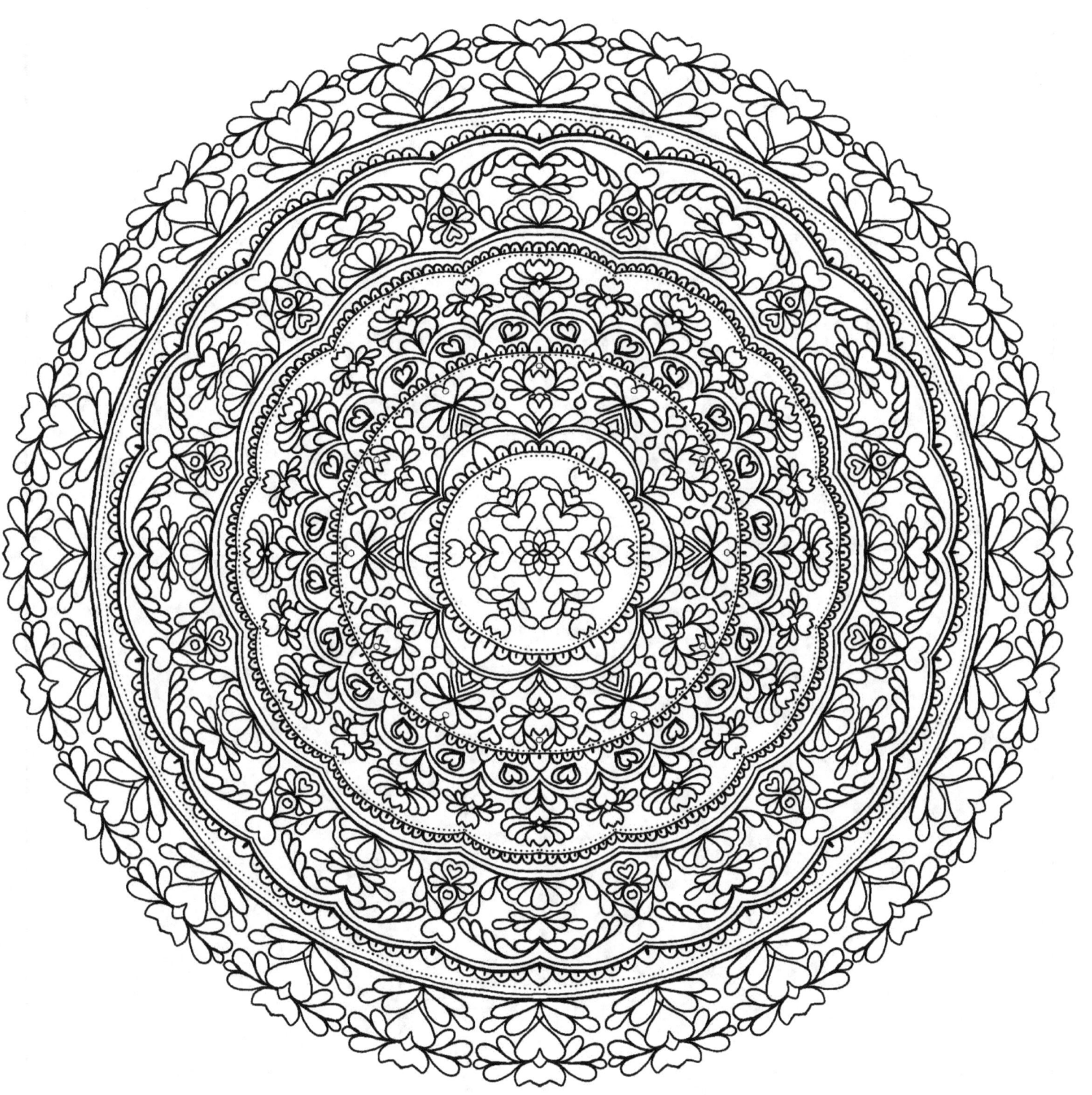

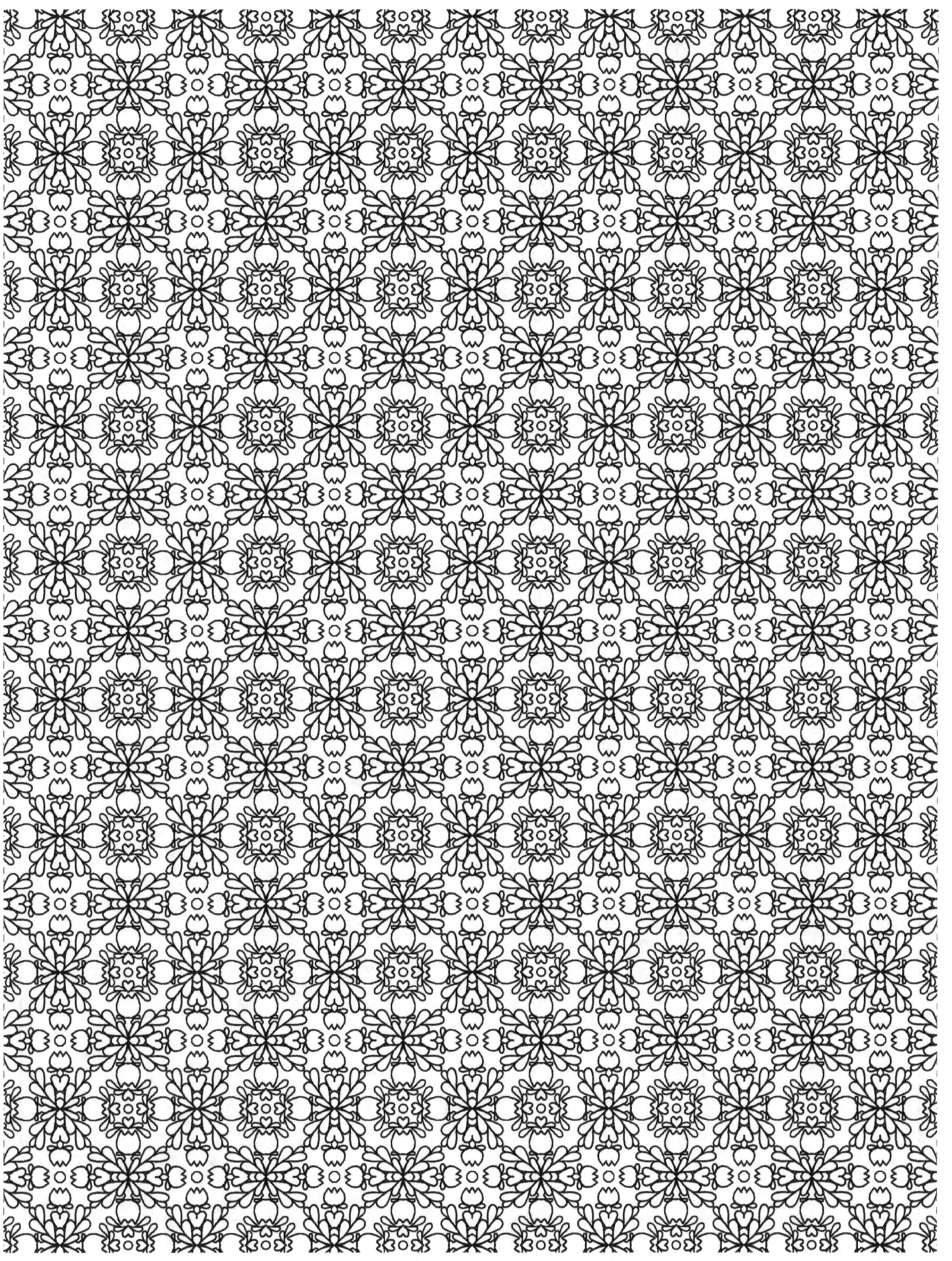

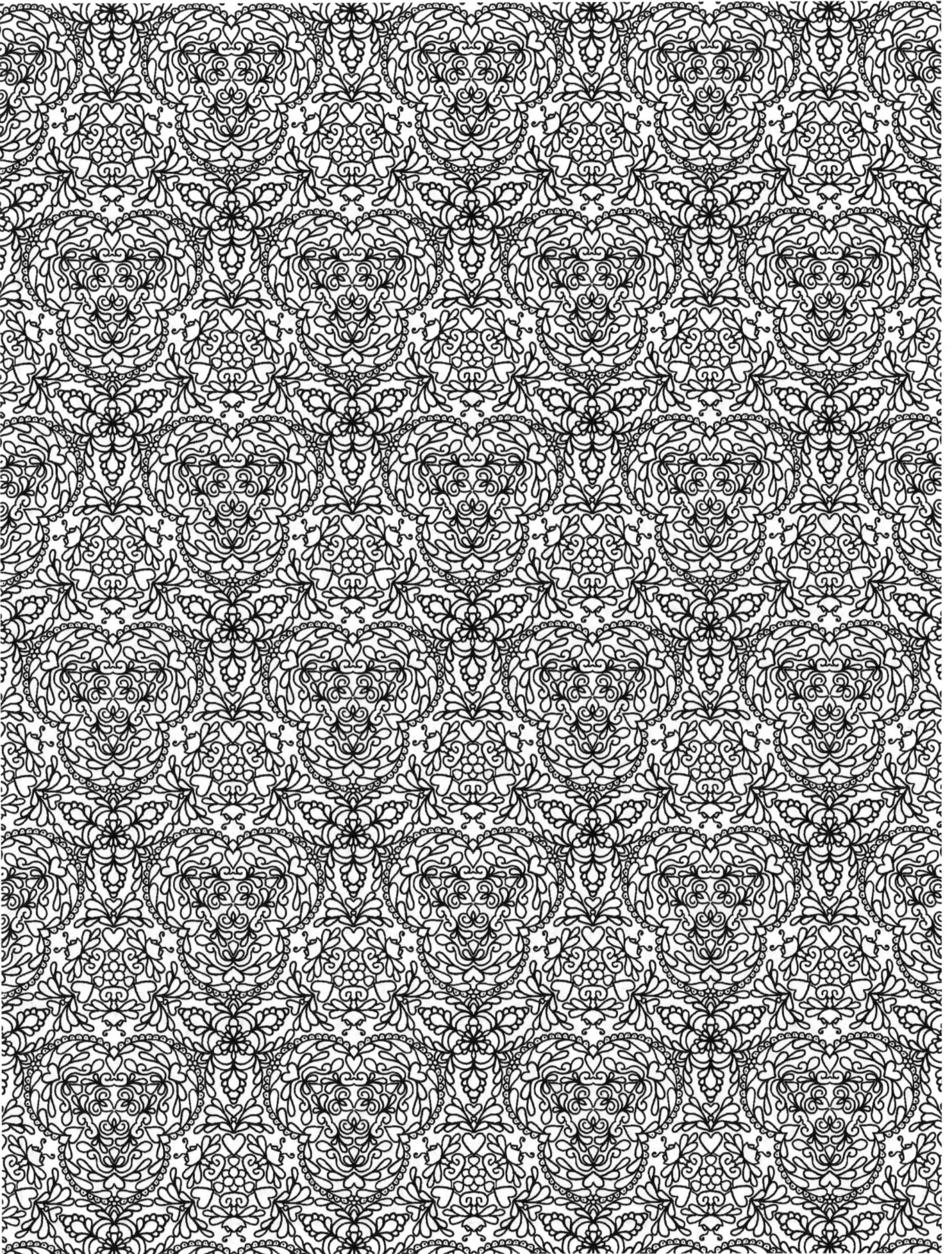

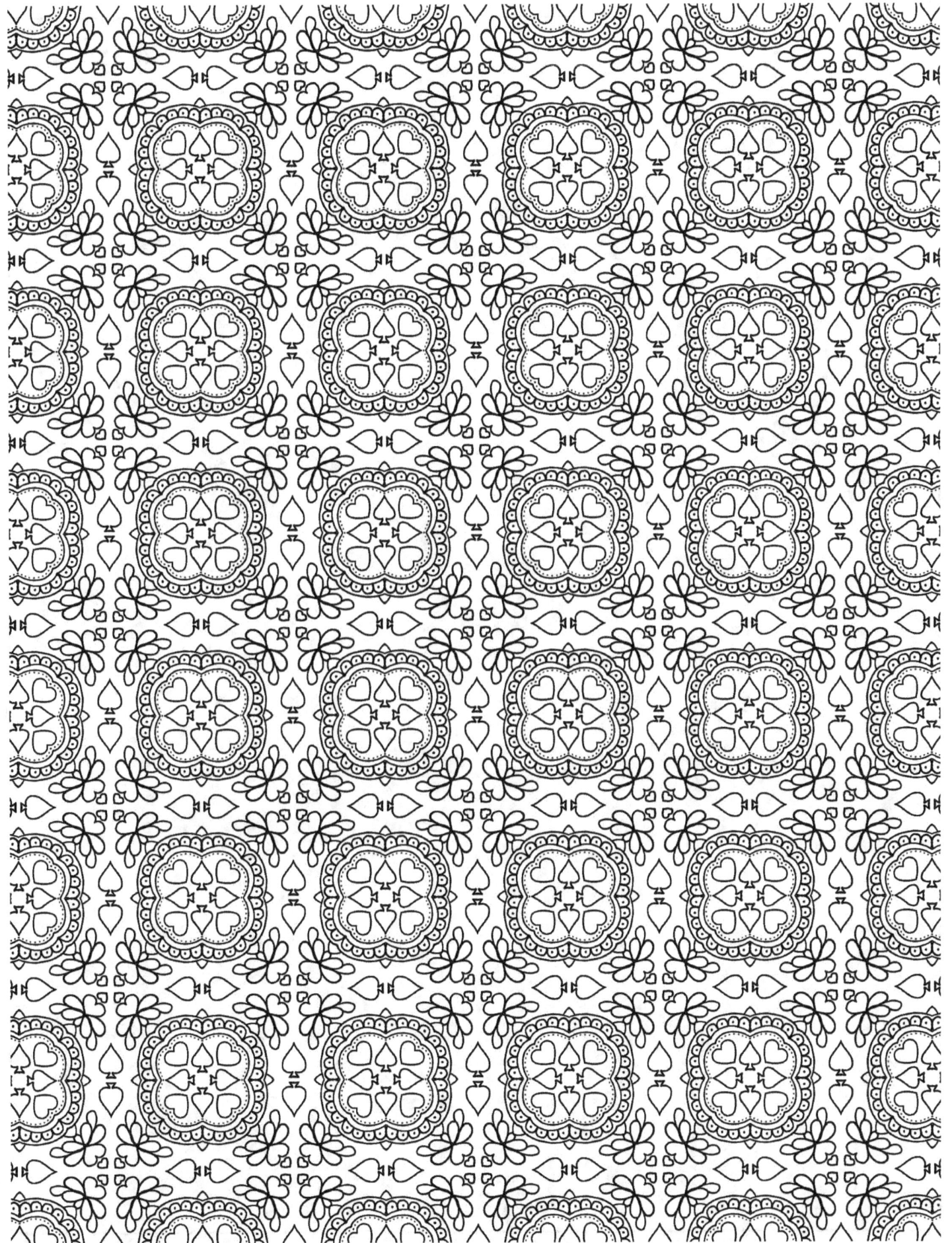

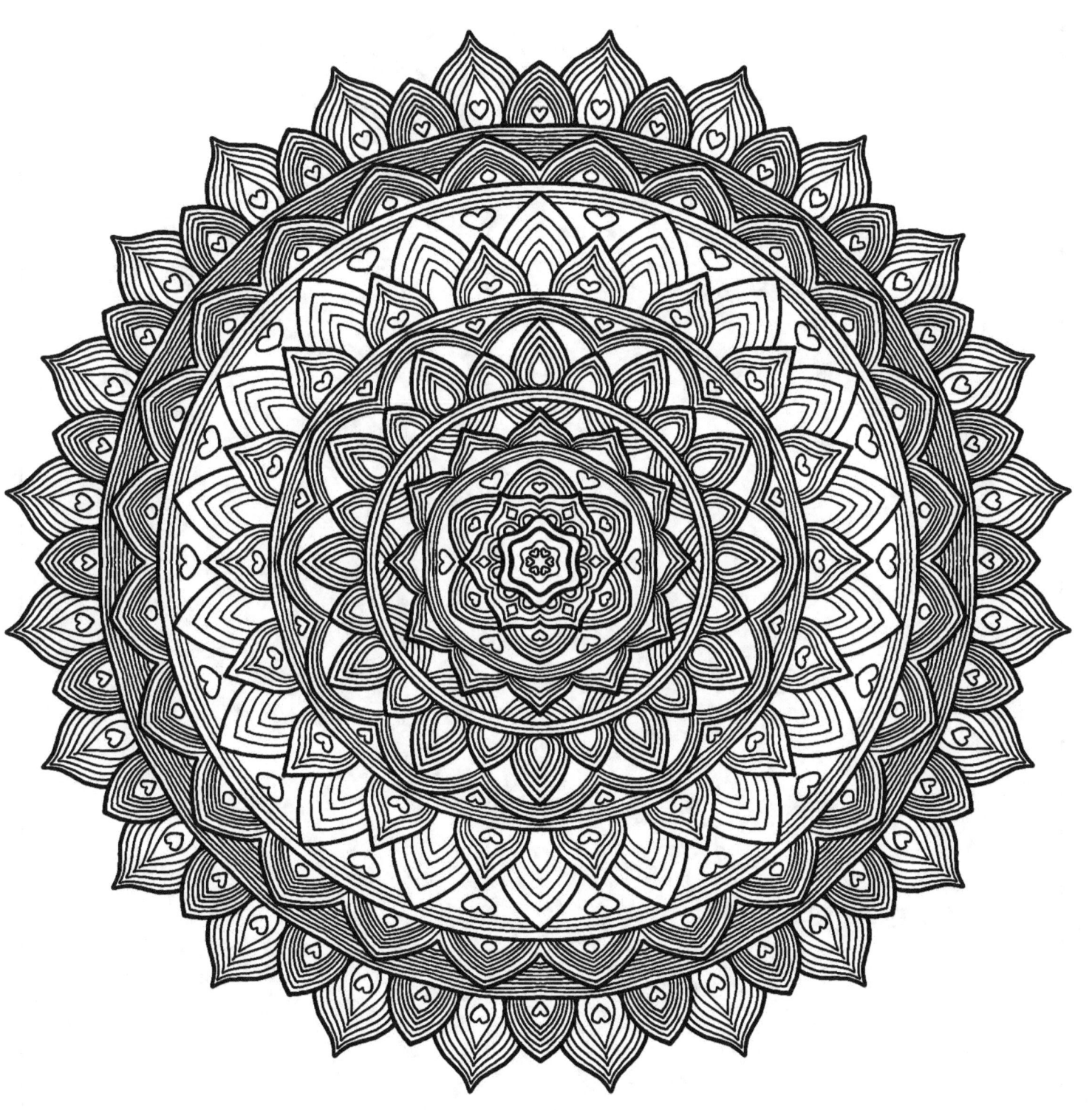

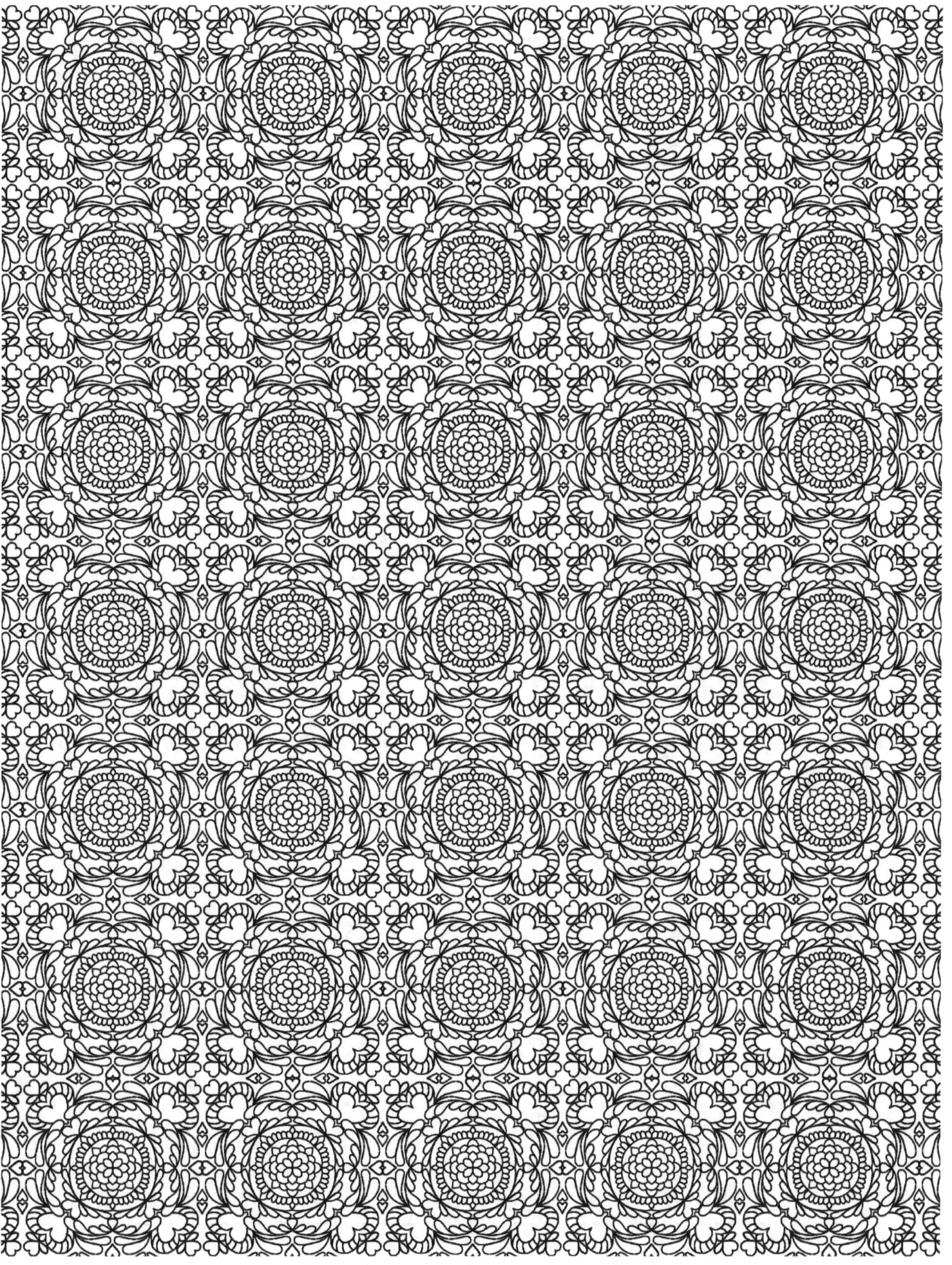

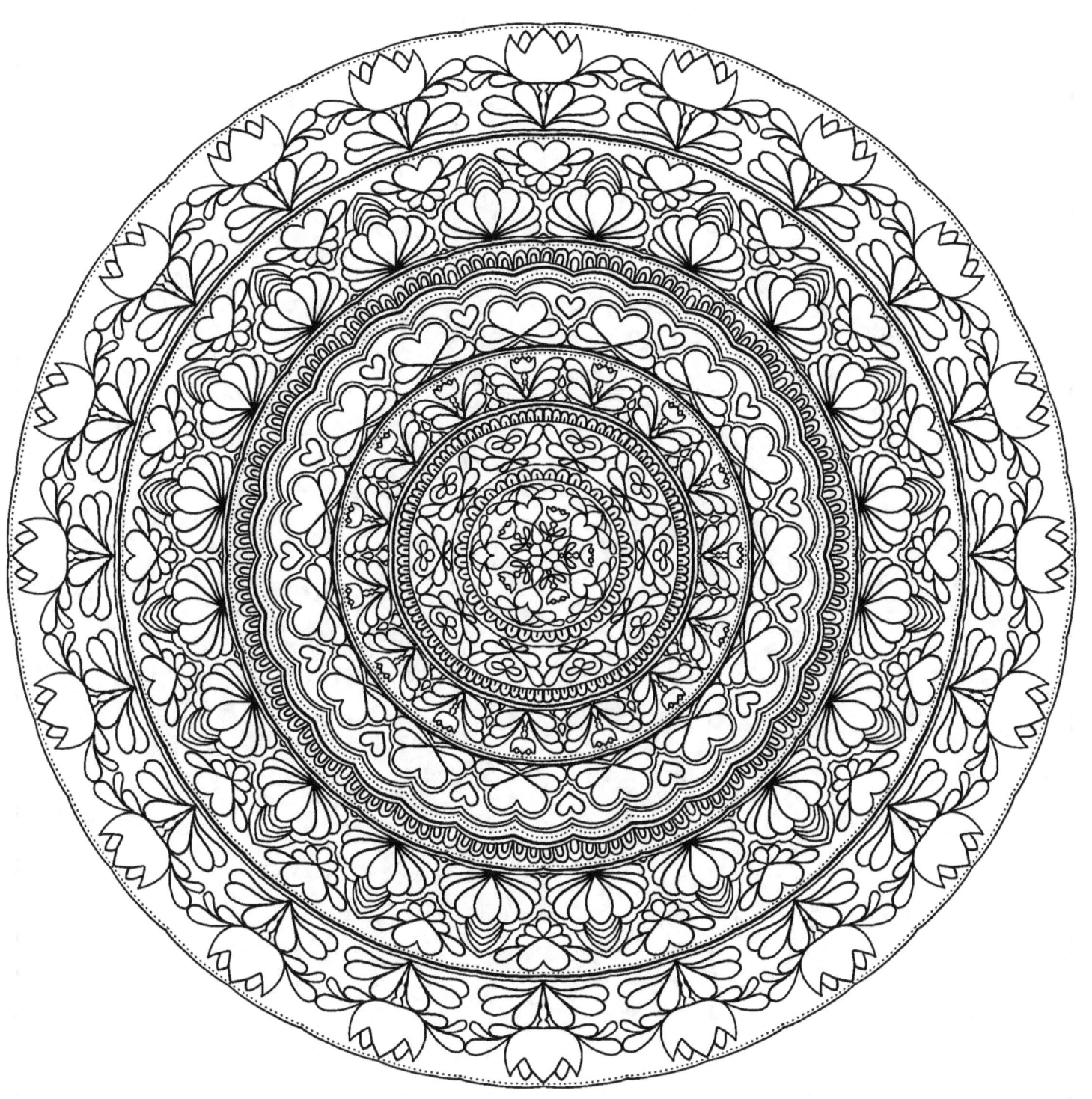

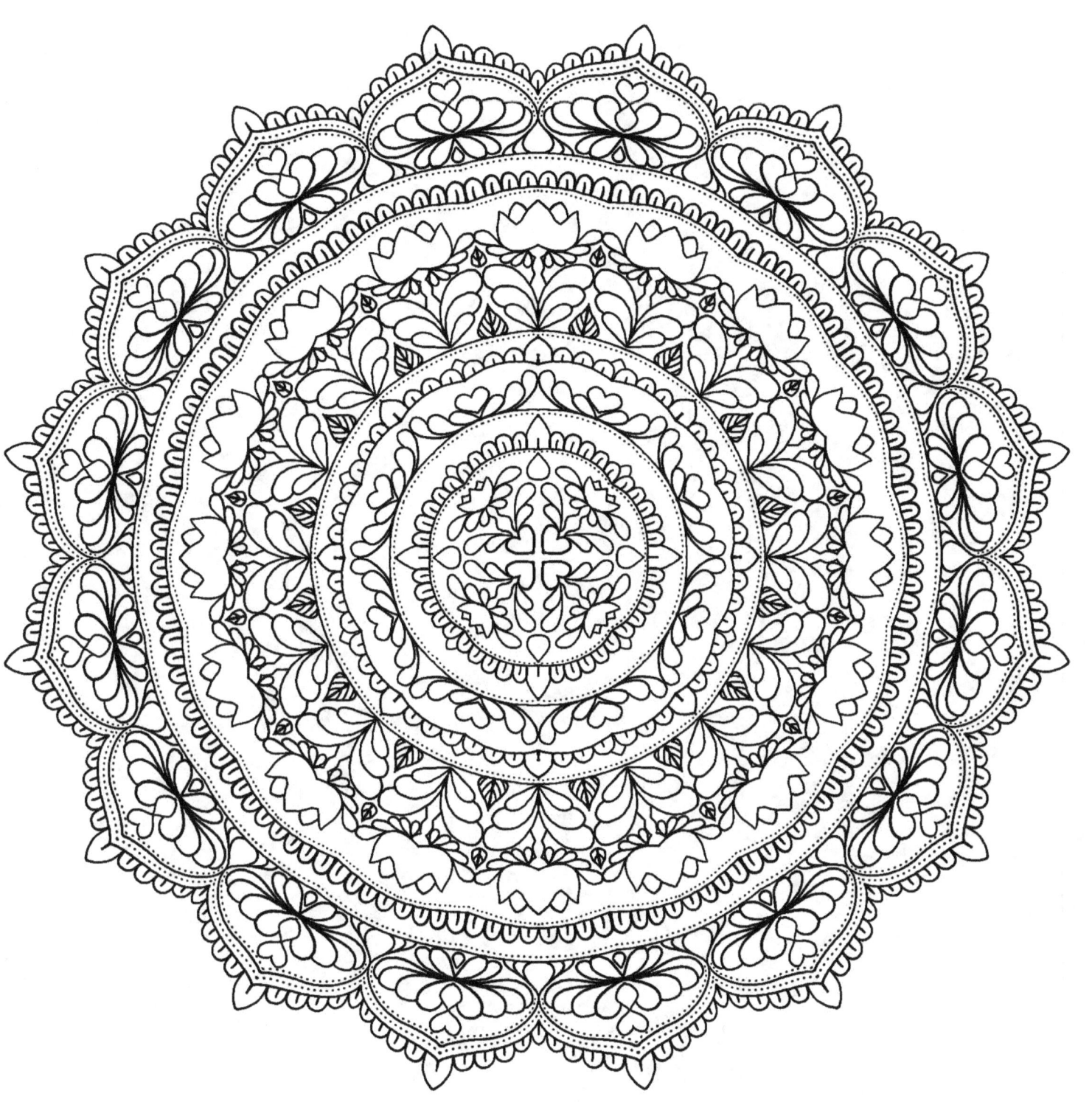

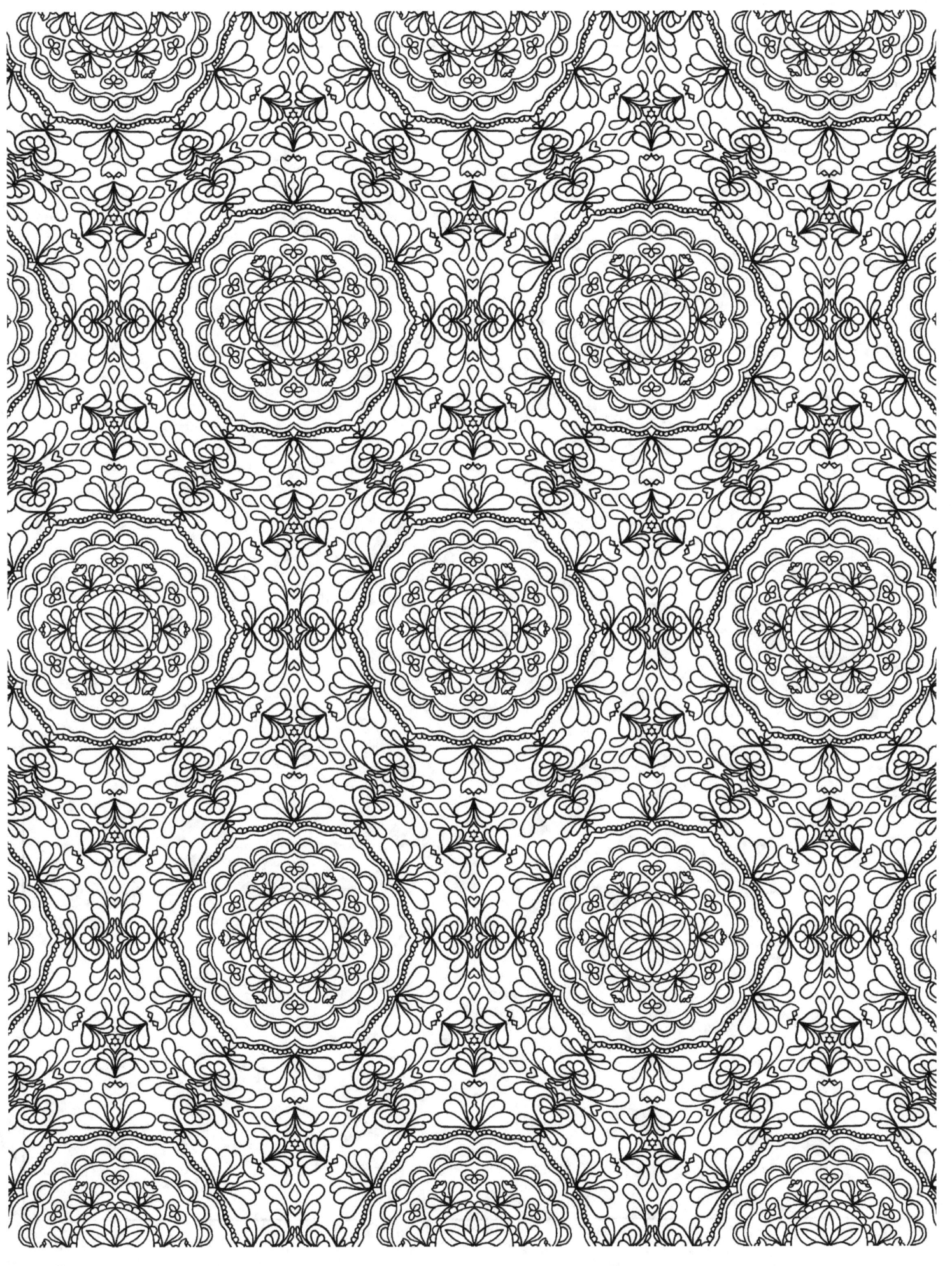

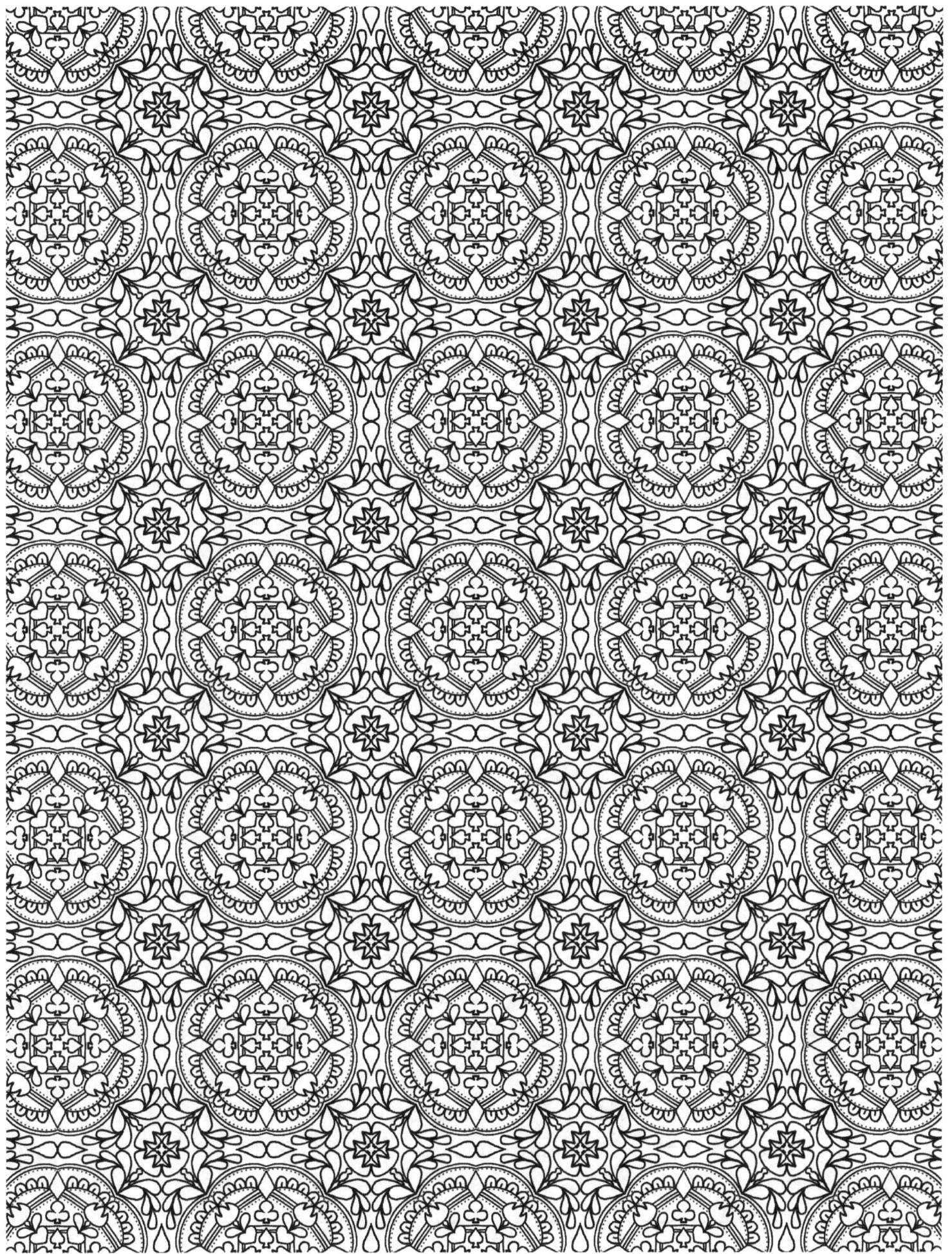

By Tin
J Art & Design
All Rights Reserved. No portion of this book may be copied in any form without the Authors Permission.
https://www.facebook.com/J.art.1157/

www.ingramcontent.com/pod-product-compliance
Lightning Source LLC
Chambersburg PA
CBHW080603220526
45466CB00010B/3234